The World War II Story

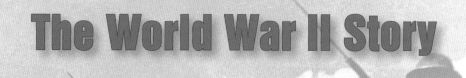

The World War II Story

Chris McNab

The
HISTORY
Press

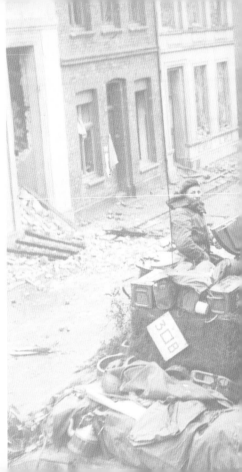

Published in the United Kingdom in 2011 by
The History Press
The Mill · Brimscombe Port · Stroud · Gloucestershire · GL5 2QG

Copyright © The History Press, 2011

British Library Cataloguing in Publication Data
A catalogue record for this book is available from the British
Library.

ISBN 978-0-7524-6205-9

Typesetting and origination by The History Press
Printed in China

0613

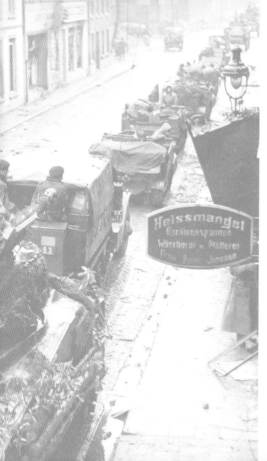

CONTENTS

ACKNOWLEDGEMENTS

I would like to thank several individuals and organizations who have been central to the production of this book. Thanks go to Ted Nevill of Cody Images, for providing many of the photos in this title, and to Jo de Vries of The History Press for the same, despite her own heavy workload. Special thanks go, as always, to my family – Mia, Charlotte and Ruby – for lightening long days.

NB: Photos credited to NARA are from the collections of the National Archives and Records Administration.

World War II is undoubtedly the most destructive military event in human history. Between 1939 and 1945, an estimated 56 million people were killed in a conflict that was truly global in scale, the theatres of war stretching from Western Europe to the Central Pacific. It included individual campaigns that alone cost more than a million lives, and incorporated human rights violations of an unprecedented nature. Unlike the previous world war, civilians would constitute the majority of the dead and wounded.

For the Allied powers – chiefly the British Empire, the United States and the Soviet Union – World War II consisted of two conflicts: that fought in Europe, North Africa and the Soviet Union against Germany, and the Pacific War against Japan. As we shall see, both had distinct, separate causes. In

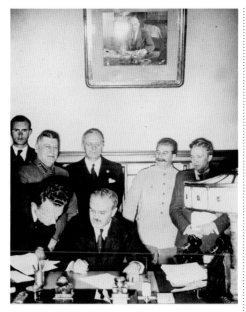

◄ The Soviet foreign minister Vyacheslav Molotov signs the German–Soviet Non-Aggression Pact on 23 August 1939. German foreign minister Joachim von Ribbentrop and Josef Stalin stand behind him. (NARA)

Europe, where it all began, however, the catalyst was undeniably a single man, Adolf Hitler. Leader of the *Nationalsozialistische*

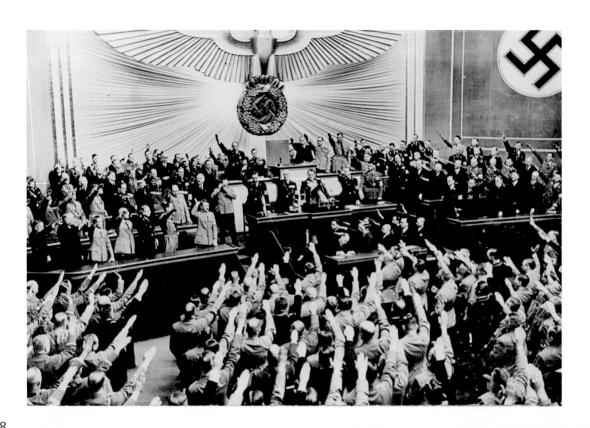

Deutsche Arbeiterpartei (NSDAP; National Socialist German Workers' Party), or Nazi Party, Hitler rose to power during the 1930s on a bitter manifesto of revenge for Germany's defeat in World War I, anti-Semitism and economic rejuvenation. Through electoral means he took the Chancellorship of Germany in 1933, then established himself as the undisputed *Führer* (leader), turning Germany into a one-party dictatorship. Hitler aspired to achieve *Lebensraum* (living space) for the German people, primarily through military conquest, and to this end he rejected the restrictions of the Versailles Treaty (the peace settlement terms imposed on Germany after its defeat in World War I) and comprehensively rebuilt not only the national economy, but also Germany's armed forces.

Did you know?
The Versailles Treaty peace settlement following the end of World War I limited German forces to 100,000 personnel, prohibited armoured vehicles, submarines and combat aircraft, and restricted the German Navy to six battleships, six cruisers and twelve destroyers.

During the later 1930s, German expansionism manifested itself in the annexation of Austria in 1938 and the takeover of most of Czechoslovakia in 1939, both 'bloodless' conquests achieved through a mixture of devious diplomacy or outright bullying. Britain, France and other nations protested, and rattled sabres, but it amounted to little more than posturing. By the autumn of 1939, therefore, Hitler felt confident of his next step, the military conquest of Poland.

◄ *Adolf Hitler receives a mass Nazi salute in the Reichstag in March 1938, following Germany's annexation of Austria. The Anschluss, as the annexation was known, was just the first stage in Hitler's expansionist ambitions. (NARA)*

Hitler's long-term aspirations for *Lebensraum* generally looked to the East, and primarily to Germany's immediate neighbour, Poland. Hitler not only wanted Polish territory for German resettlement, he also wanted to eradicate the 'Danzig Corridor', a stretch of Polish land leading to the Baltic coast and separating Germany from its easternmost state, East Prussia. In addition, Poland would provide the first big test of Hitler's *Wehrmacht* (armed forces). During the inter-war years, the army

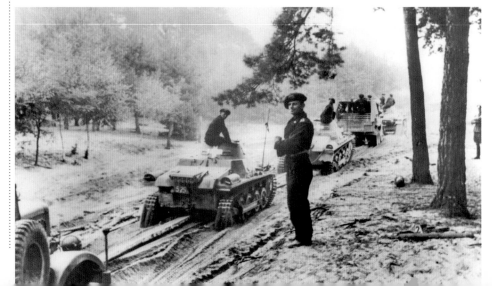

➤ *The German 1st Panzer Division, including its diminutive Panzer I tanks, enters Poland in 1939. Such tanks would be largely obsolete by the end of the campaign in Poland, being underarmed and with inadequate armour. (Cody Images)*

I was shocked at what had become of the beautiful city I had known – ruined and burnt-out houses, starving and grieving people.

– German officer Walter Schellenberg, on visiting Warsaw after its bombing

a massive pincer action, trapping entire Polish armies west of Warsaw; the capital itself was subjected to devastating air raids, and German troops reached its outskirts by 8 September. Polish resistance was not as easily dismissed as many historians have described. The obsolete Polish Air Force

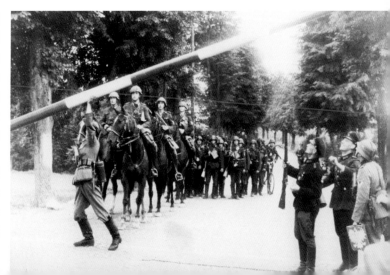

▼ *In a rather staged image, German mounted troops cross the Polish frontier in September 1939. Hitler's official excuse for invading Poland – some justification was needed – was a response to Polish aggression. (Cody Images)*

and *Luftwaffe* (air force) had pioneered combined-arms tactics, utilizing armoured spearheads to break through weak points in enemy defences, while ground-attack aircraft such as the Ju 87 Stukas served as flying artillery to smooth the way. Known to history as *Blitzkrieg*, these tactics were unleashed on 1 September 1939.

The invasion of Poland was an unequal struggle. Five German armies, arranged into two army groups, thrust into Poland from the west. The two army groups formed

put up a surprisingly tenacious defence in places, and the Polish Army fought hard enough to kill or wound more than 35,000 Germans. Yet the Poles were no match for the modern, fast-moving German divisions. Furthermore, on 17 September the Soviets invaded Poland from the east, Joseph Stalin having agreed to a partition of Polish territory with Hitler. By early October, Poland was completely under foreign occupation. It was divided between the victors, the Germans also creating a new territory known as the 'General Government', a literal slave state that would also become the principal location for Hitler's attempt to exterminate Europe's Jewish populations.

By the end of the Polish campaign, the scale of the war had widened. On 3 September, both Britain and France

Did you know?
The German–Soviet Non-Aggression Pact was signed on 23 August 1939. It openly declared a commitment not to wage war against each other for the next ten years. In secret, however, it also granted the Soviets permission to take over the Baltic States and for Germany and the USSR to divide up Poland between them.

declared war on Germany, following an unfulfilled ultimatum that Hitler withdraw his forces from Poland. Having conquered Poland, therefore, Hitler now turned his eye to the West. With future ambitions against the Soviet Union, he knew that he couldn't leave his western borders unsecured, so Germany would once again fight old adversaries.

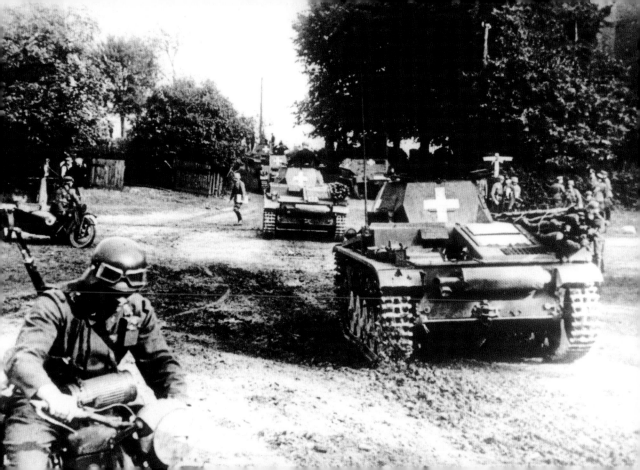

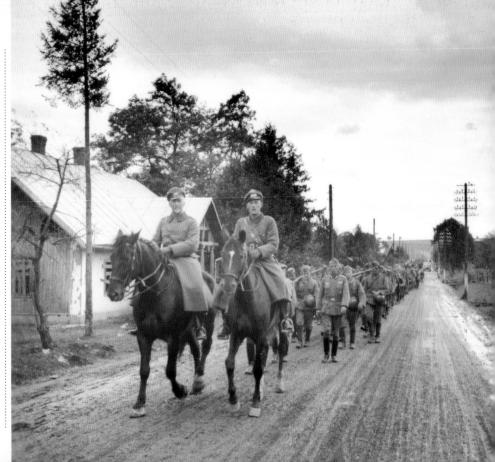

► Although the Wehrmacht *was a highly mechanized army, the bulk of its forces – including these troops advancing into Poland in 1939 – still relied upon foot power and horse power. (Cody Images)*

◄ *German troops, in an open display of triumphalism, march through Warsaw following the defeat of Poland in 1939. The Polish campaign, however, brought both Britain and France into the war. (NARA)*

The period between October 1939 and April 1940 is typically referred to as the 'Phoney War', a stretch of relative inactivity between the Western Allies and Germany. There were minor air raids and naval skirmishes, but no significant campaigning. The Soviets, by contrast, acted on long-standing enmities by invading Finland on 30 November 1939. The Soviet Army dwarfed that of Finland, but the so-called 'Winter War' nevertheless ran on until March 1940, the hardy and tactically innovative Finns inflicting more than 200,000 dead on the Soviets before they capitulated. Finland was forced to cede large amounts of territory to the Soviets, including the Karelian Isthmus, but Hitler noted the general inferiority of Soviet forces when faced by well-trained troops.

CAMPAIGN IN THE WEST

The 'Phoney War' came firmly to an end on 9 April 1940, when Hitler's forces embarked on a series of campaigns in the West that brought stunning levels of success. Denmark and Norway were the first targets. Denmark collapsed on the day it was invaded, but the Battle of Norway saw more substantial intervention from the British and the French, including raids by the Royal Navy against German shipping around Narvik, sinking ten destroyers and several other vessels. The battle rumbled on until early June, but the Allied retreat from Norway in May – largely due to events described below – resulted in the replacement of the British Prime Minister, Neville Chamberlain, by one Winston Churchill, a man who would have a seminal influence on the future direction of the war.

Even as fighting continued in Norway, Hitler opened what would be his decisive campaign in the West, the invasion of France, Belgium and the Netherlands. Here the *Wehrmacht* would face the British and French armies in a greater struggle.

On paper, the opposing forces were roughly even – 139 German divisions against 149 Allied divisions, the latter including nine divisions of the British Expeditionary Force (BEF). Yet the German Army had

◀ *A German Panzer IV tank hides under the canopy of the Ardennes forest, Belgium, waiting to strike into France in May 1940. The attack through the Ardennes bypassed the French Maginot Line fortifications. (Cody Images)*

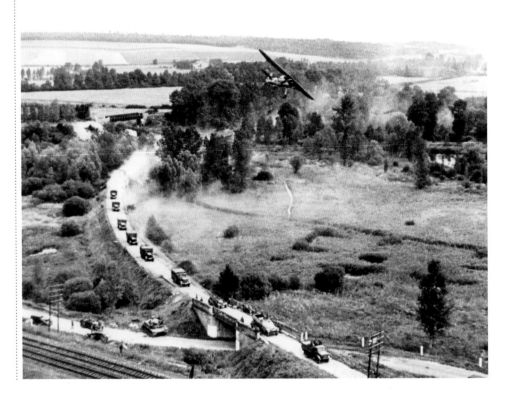

➤ *A mechanized column of Rommel's 4th Panzer Army advances through France in 1940, and a reconnaissance aircraft flies overhead. German forces pioneered air–ground combat communications. (Cody Images)*

a tactical superiority in armour, bombers and fighters, its infantry were more highly trained, and its post-Poland confidence was running high. France, by contrast, staked much of its defensive hope upon its Maginot Line defences running from the Swiss/French border to Luxembourg, plus the supposedly impenetrable natural defence of the Ardennes forest to the north of the line. The German plan, however, was based on a strong thrust down through Belgium and the Netherlands, drawing the Allies north, then pushing through the Ardennes, across the Meuse and driving on across France to the coast, cutting off the Allied forces who had deployed north.

The offensive began on 10 May 1940, and showed *Blitzkrieg* in perfect operation. The German 4th, 6th and 18th armies invaded the Netherlands and Belgium on 10 May 1940. Paratroopers – a new force within the *Wehrmacht* – performed airborne raids to capture key bridges and airfields ahead of the land advance; on 11 May one glider assault also captured the mighty Belgian fortress of Eben Emael at Liège. As predicted, Allied forces (the BEF and the French 1st, 7th and 9th armies) swung north to meet the threat. As they were doing so, the German 16th Army took Luxembourg in short order while the 12th Army surged through the Ardennes, heading for the gap in the Allied forces between Sedan and Dinant.

Driving on at a pace that sometimes alarmed even the German commanders themselves, the armoured forces crossed the Meuse River and pushed into the French hinterland, advancing on a relatively narrow front towards the sea and cutting

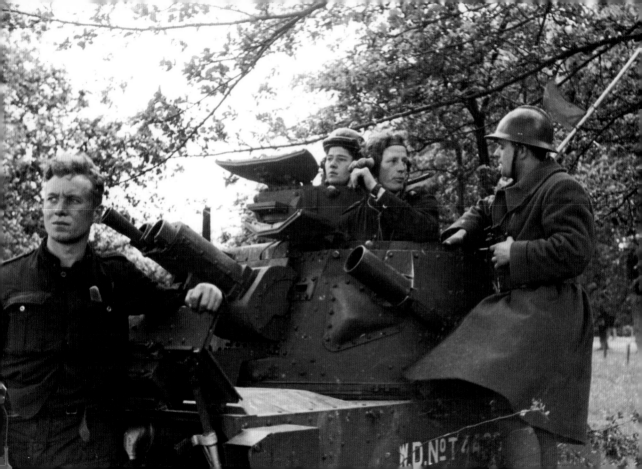

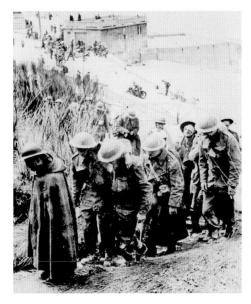

Did you know?

The concrete and steel Belgian fortress of Eben Emael was garrisoned by around 700 men, but was captured largely by seventy-eight German paratroopers, who used special shaped-charge cutting explosives to destroy many of the emplacements.

◄◄ French and British troops liaise during the disastrous campaign against German forces in France, 1940. Both sides were consistently outmanoeuvred and outgunned by the more competent enemy divisions. (Cody Images)

◄ Disconsolate British and French troops, many of them wounded, file across the beaches of Dunkirk, France, awaiting their evacuation to Britain and escape from the advancing German forces. (NARA)

20 May, and an Allied attempt the next day to sever the German advance near Arras failed. German forces now began driving northwards, trapping the BEF against the coast around Dunkirk.

France could not be saved. By 28 May, the Low Countries had fallen, and French forces were incapable of containing the *Blitzkrieg*. There was one glimmer of hope for the Allies. The British, in a legendary

off the BEF and the French 1st Army to the north. Allied responses were slow, chaotic and ineffectual. The first German troops reached the sea, near Abbeville, on

effort, managed to evacuate 338,226 men from Dunkirk in the face of a furious onslaught by the *Luftwaffe*, ensuring that the British would be able to fight another day. The war in southern France continued, but German forces crossed the Seine on 10 June – incidentally the same day that Germany's fascist ally Italy entered the war – and took Paris four days later. On 22 June, Marshal Philippe Pétain signed the Armistice that signalled the French surrender.

With the monotonous regularity of metronome beats, one shell followed another, and the blasts became more violent as the shells fell closer and closer…. There was little that could be said to comfort one another.

– *Lars Moen, on the shelling of Antwerp in 1940*

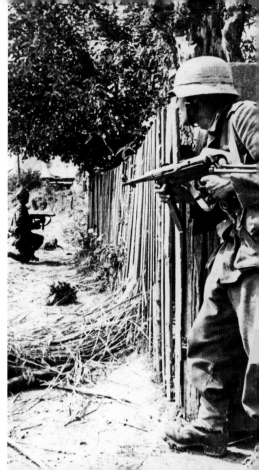

BATTLE OF BRITAIN

Militarily, Hitler's achievements were extraordinary. In 10 months he had brought Europe, from Poland to the Atlantic coast, under his domination, acquiring vast amounts of manpower, raw materials and industrial resources in the process. His armed forces seemed unassailable.

A thorn remained in the German side, however. Britain stood obstinately alone. Hitler harboured visions of a German and British alliance, but the defiant oratory of Winston Churchill declared nothing but implacable resistance. Only 20 miles (32km) of English Channel now separated occupied France from Britain, and the British Army was critically weakened by military unpreparedness and its disaster in France. On 16 July, Hitler issued Führer Directive 17 authorizing Operation *Sealion*,

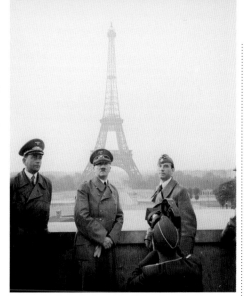

◄ *Hitler stands triumphant before the Eiffel Tower in Paris on 23 June 1940, his armed forces having conquered France and, temporarily, defeated the British in less than two months. (NARA)*

the invasion of Britain, scheduled for the following September. For the invasion to make a successful amphibious crossing and landing, however, Britain's air force had to be subdued. To this end, Reichsmarschall Hermann Göring, the head of the

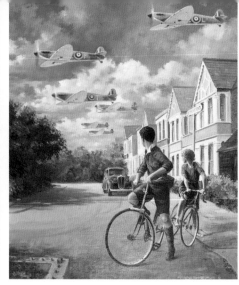

A British anti-aircraft gun opens fire during the Blitz. Such barrages rarely brought down enemy aircraft, but they did serve to disrupt the bombers' flight paths and bomb runs. (Courtesy of Roy Conyers Nesbit, The Battle of Britain)

Luftwaffe, promised that his fighter and bomber crews would crush the RAF and the British capacity to resist in just a few weeks.

The Battle of Britain – one of the greatest sustained air battles in history – began in earnest on 10 July, at first with attacks on British shipping in the Channel but then widening to a full-blown onslaught against RAF bases, radar stations and aircraft production centres. Yet, although the *Luftwaffe* was at the peak of its strength – 2,830 aircraft were deployed against Britain in July – it failed to subdue the RAF or the British will to fight. The Spitfires

and Hurricanes of RAF Fighter Command took a heavy toll on the German aircraft in the summer skies, and British fighter production managed to keep pace with the RAF's own heavy losses. (Replacing dead or wounded pilots was a far greater problem.)

Göring also made a fatal error. Just as the RAF was weakening, on 7 September he switched the focus of the campaign to bombing London, and then other British cities. This change gave the RAF a much-needed reprieve, and the losses to German aircraft mounted unsustainably in September. From 7–16 September, for example, 175 *Luftwaffe* aircraft were destroyed. It was clear that Göring's objective of destroying the RAF had failed, and in October Hitler indefinitely postponed *Sealion*. The Battle of Britain went on until the end of the month,

Did you know?

Although the Supermarine Spitfire was undoubtedly the most capable fighter plane in the RAF during the Battle of Britain, it was the slower, less manoeuvrable Hawker Hurricane that achieved the greater number of combat kills.

being replaced thereafter by the night-time bombing campaign of British cities known to history as the 'Blitz'. During the campaign, the *Luftwaffe* had lost about 1,300 aircraft, to nearly 800 RAF losses. It was Germany's first major defeat of the war. In the long run, Hitler's failure to take Britain would have catastrophic results for Germany.

◄ *In this highly evocative artwork, Supermarine Spitfires mesmerize two British boys as they fly over their village. The Spitfire was the RAF's premier fighter aircraft during World War II. (Courtesy of Roy Conyers Nesbit,* The Battle of Britain*)*

In 1940 the war expanded into entirely new theatres beyond Western Europe. The Balkans, that most historically turbulent of world regions, would also become soaked in blood, as would North Africa and much of the Mediterranean. The European war was starting to become a world war.

Fascist forces already had a foothold in the Balkans through Italy's invasion and occupation of Albania in 1939. From this platform, Mussolini then launched his army into Greece on 28 October 1940, confident of a quick victory. It was not to be. After initial advances, the Italian Army

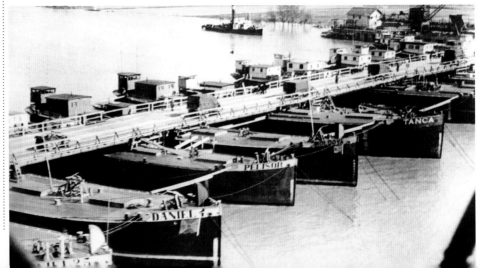

➤ *During the German campaign in the Balkans, army engineers display their talents in the form of a pontoon bridge, supported on a succession of boats, across the River Danube in March 1941. (Cody Images)*

was stopped by vigorous Greek resistance, then forced to retreat back into Albania.

Hitler watched events unfolding with concern. By this time preparations for the German invasion of the Soviet Union were well under way, and Germany needed a secure Balkans to prevent a weak flank in the south. Romania, Hungary and Bulgaria had joined the Axis cause, but a short-lived pro-Nazi regime in Yugoslavia was overthrown in a coup, and the Italian campaign in Greece had collapsed.

The Nazi masters of Germany have made it clear that they intend not only to dominate all life and thought in their country, but also enslave the whole of Europe, and then use the resources of Europe to dominate the rest of the world.
– President Roosevelt, 29 December 1940

On 6 April 1940, the German 12th Army invaded both Yugoslavia and Greece, and was later supported by Italian and Hungarian forces. Yugoslavia's obsolete army was unable to resist, and the government surrendered on 17 April. (The subsequent guerrilla war in that country, however, would endure until the end of the war and cost more than a million lives.) German troops also advanced confidently down through Greece, despite the deployment of more than 55,000 British, Polish and Commonwealth troops under Lieutenant-General Maitland Wilson, to help bolster the resistance. Multiple strands of advance destabilized the Allied lines of defence, and both Greek and British forces began a painful retreat down the Greek mainland. The Greek 1st Army surrendered on 21 April, and two days

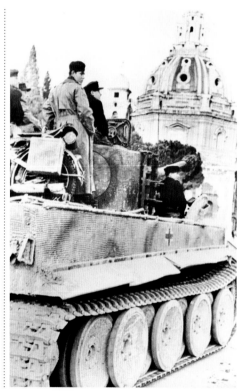

➤ *A Tiger tank rolls through a street in Greece. The ribbed surface on the hull is created by the application of Zimmerit paste, which repelled magnetic mines. (Cody Images)*

later the British began yet another major evacuation operation, moving 43,000 men from southern Greece and the Peloponnese out to the island of Crete.

Germany had added another two nations to its list of conquests. The following May, in a landmark airborne operation, it also invaded and seized Crete, although at high cost.

Did you know?

Such were the losses amongst German paratroopers during the Battle for Crete – 7,000 killed – that they were almost never used again in land-scale airborne actions.

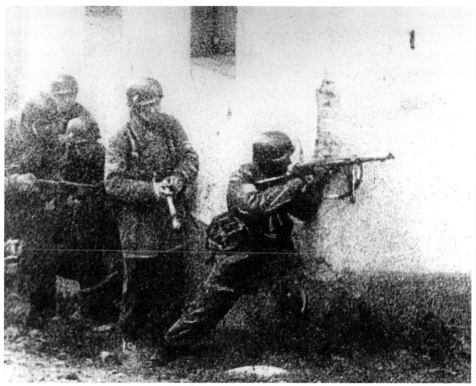

◄ A grainy image of German paratroopers fighting on the streets of Crete in May 1941. The Fallschirmjäger *were a true elite within the* Wehrmacht, *and were officially a* Luftwaffe *not an army formation. (Cody Images)*

By the time that Crete fell, fighting in North Africa was also in full swing. Both Italy and Britain had colonies in North Africa, the Italians in Libya and the British in Egypt and Palestine. The Italian 10th Army invaded Egypt in September 1940, but were decisively driven back by the Operation *Compass* counter-attack the following December, which by 9 February 1941 had advanced 500 miles (800km) along the Mediterranean coast, taking the major ports of Tobruk, Derna, Barce and Benghazi in the process. Italian resistance disintegrated, and eight divisions were lost, mostly in the form of tens of thousands of prisoners. The British advance stopped at El Agheila, at which point units were siphoned off to assist in the futile defence of Greece.

The tank battles around us had not gone our way. In spite of our new tanks with the bigger armament and thicker armour, the 88mm dual-purpose gun was proving deadly.
– *Brigadier L. Bolton, on armoured warfare in North Africa*

In February 1941, once again fulfilling a rescue mission for Italy, Germany entered the fray in the Western Desert, under the command of the soon to be legendary General Erwin Rommel.

General Rommel had to adapt quickly to the North African theatre, which he did. The vast expanses of uninhabited desert, and the apolitical professionalism of Rommel's *Deutsche Afrikakorps* (DAK; German Africa Corps), made the Western Desert

◄ *Rommel's tanks advance across the Western Desert in March 1942. The dust trails raised by vehicles in the desert became convenient markers for enemy ground-attack aircraft. (Cody Images)*

campaign a 'clean' one in soldiery terms, in which the war was fought largely without the tragic involvement of civilians. Yet the desert itself was an enemy, taking a heavy toll on vehicles, aircraft and personnel, and often providing little in the way of natural cover and protection from enemy flanking manoeuvres. The action took place along hundreds of miles of coastal strip, interspersed infrequently by crucial supply ports. War in this theatre, therefore, became utterly dependent on supply chains, which for both sides stretched with every advance but fattened with every retreat. In the Mediterranean Sea, Allied warships and aircraft clashed with Axis counterparts as each side attempted to keep their maritime supply lines open.

The supply situation, plus the vagaries of each campaign, resulted in a highly elastic frontline. At first Rommel, establishing a reputation for brilliant leadership, undid all Allied gains in an offensive that pushed the British back into Egypt by late April (although Tobruk held out, isolated and besieged). Two British offensives – *Brevity* and *Battleaxe* in May and June respectively – cost the British heavy losses for no significant gains, but the *Crusader* offensive of a reinvigorated British Army (under

Did you know?

Erwin Rommel was one of Germany's greatest military commanders. In October 1944, on Hitler's orders, he was forced to commit suicide, having been linked with a plot to kill Hitler the previous July.

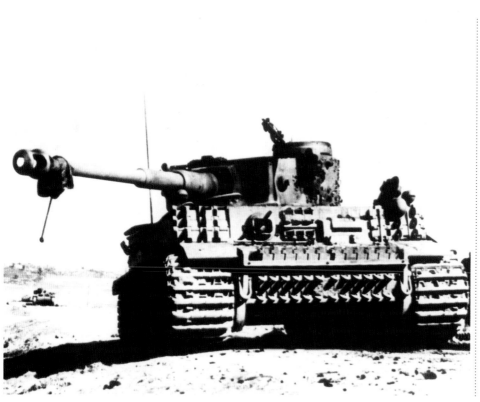

◄ *A knocked-out Tiger tank in North Africa. The much-feared Tiger was first combat-tested on the Eastern Front, but then small numbers were sent to Tunisia in late 1942, where they were plagued by mechanical troubles. (Cody Images)*

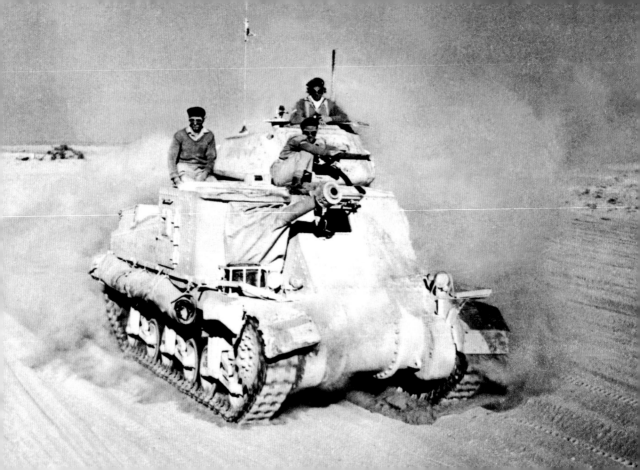

the new command of General Claude Auchinleck), beginning on 18 November, drove Rommel all the way back to his start line by early January 1942.

During 1942, the North African seesaw swung two more times. The German–Italian *Panzerarmee Afrika* (Panzer Army Africa), of which the DAK was now a part, counter-attacked on 21 January, reaching El Alamein in Egypt at the end of June. Yet here was the high point of Rommel's achievements in the theatre. The long advance had exhausted his army and attenuated his logistics. (By this time, the Germans were fighting their massive war on the Eastern Front, which took the lion's share of manpower, fuel, vehicles, armour and supplies.) The British, by contrast, substantially reformed and rearmed, and had once again changed command

relations. After he repulsed a German attack at El Alamein, Auchinleck was replaced by General Harold Alexander, with the tenacious General Bernard Montgomery as commander of the British 8th Army.

'Monty' fought off a German onslaught at Alam Halfa in late August and early September, then spent a month building up his resources for an epic offensive, launched on 24 October. At the Second Battle of El Alamein, a massive British artillery barrage and armoured attack once again put the Germans into a general retreat. This time, they would not recover.

The Germans were driven across the entire length of North Africa into Tunisia. Here they faced a new enemy – the United States, which had invaded North Africa via Morocco and Algeria along with additional British forces in Operation *Torch*

A British tank crew rides upon their Lee/Grant tank in North Africa. The desert sand and dust created severe problems for armoured vehicles, with issues ranging from worn engines to blocked air filters. (Cody Images)

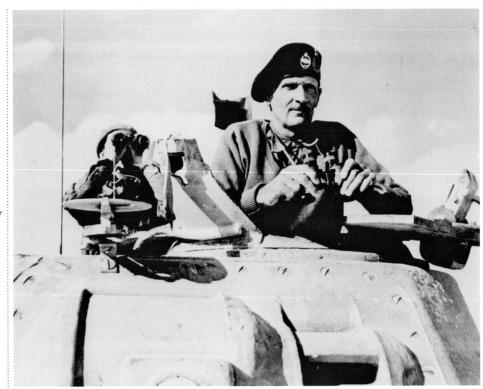

➤ Bernard Montgomery rose to fame as the commander of the British 8th Army in the Western Desert, and later in Sicily and Italy. His victory at the Second Battle of El Alamein in October and November 1942 began the defeat of Rommel in North Africa. (NARA)

➤➤ British troops advance past a destroyed German Panzer IV tank, with a dead crew member sprawled on the hull. Note the extreme length of the bayonets fitted to their Short Magazine Lee-Enfield (SMLE) rifles. (Cody Images)

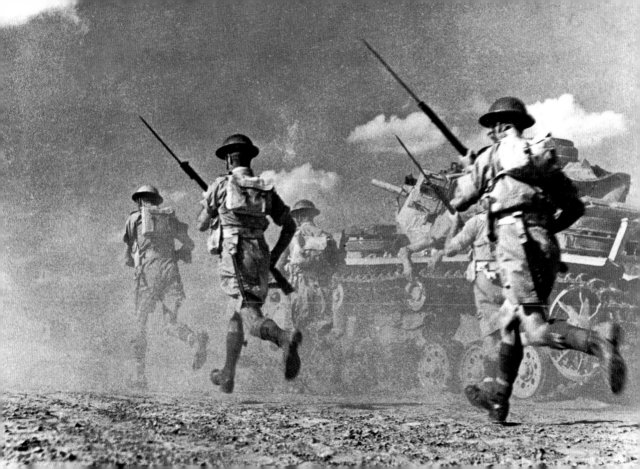

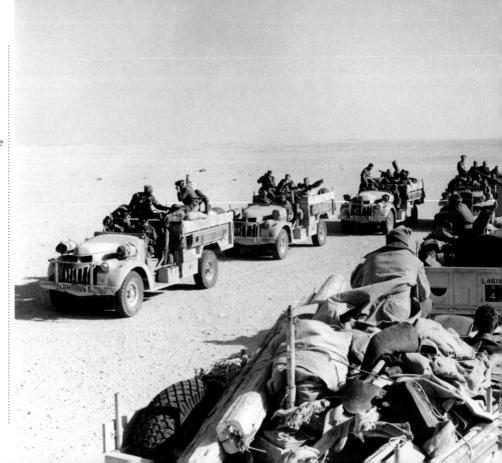

➤ A column of British troops from the Long-Range Desert Group (LRDG). The LRDG was used to make fast attacks against remote enemy positions, and they laid the groundwork for future Special Forces tactics. (Cody Images)

on 8 November 1942. Although the green Americans' first major clash with the veteran Germans resulted in a bitter US defeat at Kasserine in mid-February 1943, the US troops soon gathered confidence. Caught in a two-front war, and having completely lost air superiority, German forces were eventually squeezed out of North Africa altogether by 12 May. Tens of thousands of German and Italian troops managed to evacuate from the northern tip of Tunisia to Sicily and Italy, but 250,000 others became prisoners of war.

Did you know?
Commonwealth troops constituted a very high percentage of 'British' forces in North Africa. The Australians alone contributed 100,000 men to the theatre.

The failure to hold on to North Africa was a major defeat for the *Wehrmacht*, but at this stage of the war it had even greater problems on its hands much further north.

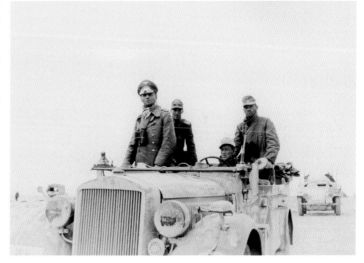

▼ *Erwin Rommel rides in a staff car in North Africa. Rommel was a true combat leader, often placing himself in harm's way and leading from the front, even when his health was poor. (NARA)*

While the war in North Africa was fought largely free from governing Nazi ideology, the polar opposite was true of Germany's war against the Soviet Union. Hitler's political writings as far back as the 1920s made it clear that he regarded the Soviet people as politically and racially inferior to the Germans, labelling them as *Untermenschen* (sub-humans). But the vast spaces of Russia and the Ukraine, offering food and raw materials in unimaginable quantities, made the conquest of the Soviet Union the centrepiece of Hitler's aspirations for *Lebensraum*.

Joseph Stalin, the Soviet dictator, had an enormous army at his disposal – 230 divisions; around 5 million men (2.9 million immediately facing the German invasion); up to 20,000 tanks (of all types); 10,000 aircraft. Many of these figures dwarfed the German forces allocated for the invasion – 3.5 million men, 3,350 tanks, and 2,770 aircraft – but they masked serious problems within Soviet capabilities. During his infamous political purges of the 1930s, Stalin had removed 35,000 officers, leaving the Red Army with extremely poor leadership down to division and even battalion level. Stalin was also convinced that Germany would not invade – it took German armour

➤ A company of Red Army infantry, seen in 1941. The early performance of the Soviet Army was generally weak. Although the soldiers fought with passion, they were badly led and often poorly equipped. This problem was only remedied later in the war. (NARA)

Did you know?
The best Soviet tank of the war was the T-34. Armed with a 75mm gun, it was fast, manoeuvrable, mobile over soft ground, reliable and with decent armour. Its appearance on the battlefield was one motivation behind the Germans' development of the Panther tank.

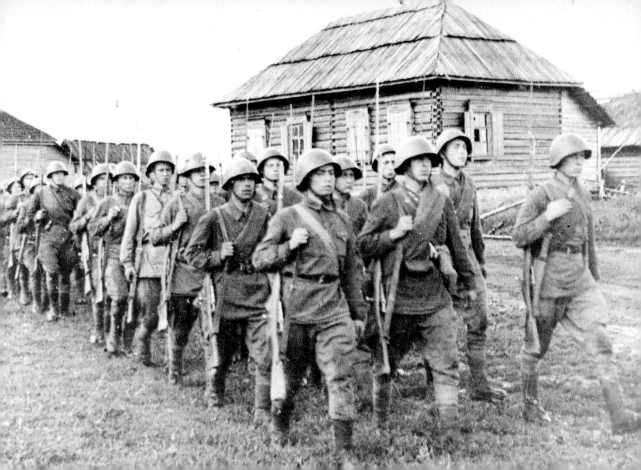

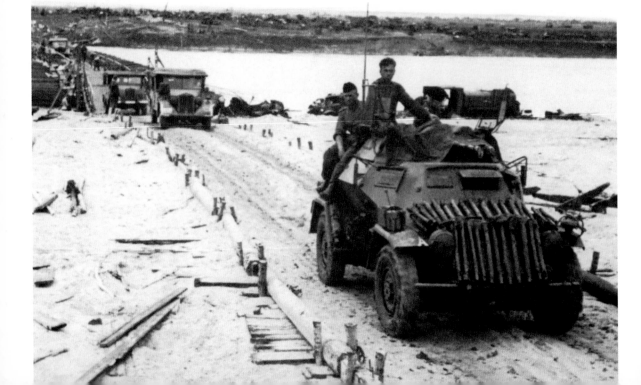

rolling across his frontier to convince him otherwise. Much Red Army equipment was obsolete, and a rearmament programme had not been completed. Furthermore, many of the westernmost Soviet Army 'fronts' (roughly equivalent to an army group) were stationed very close to the Soviet border, where they were vulnerable to German encirclement tactics.

Operation *Barbarossa*, as the invasion was known, began on 22 June 1941. The front of attack was enormous, stretching from the Black Sea to the Baltic Sea, and was the start point for three German Army Groups – North, Centre and South. Army Group North pushed through the Baltic States towards Leningrad; Army Group Centre through Belorussia along the axis of the main Moscow highway; Army Group South attacked south and south-west into the Ukraine.

The Soviets were overwhelmed by the pace and professionalism of the invasion. Hundreds of thousands of troops were killed or taken prisoner – Army Group Centre captured some 300,000 prisoners alone when its pincers closed east of Minsk on 29 June. Similar disasters stacked up during July–September, including the destruction of the entire 5th and 37th armies – 500,000 men – just east of Kiev, between 15 and

> We suddenly saw a broad, earth-brown crocodile slowly shuffling down the road towards us. From it came a subdued hum, like that of a beehive. Prisoners of war. Russians, six deep.
>
> – *Benno Zieser, a German witness to Operation* Barbarossa

◄ A German motorized column moves across a river into the Russian hinterland. The sheer distances involved with advancing across the Soviet Union meant that the Blitzkrieg *tactics used in Western Europe were far less effective on the Eastern Front. (Cody Images)*

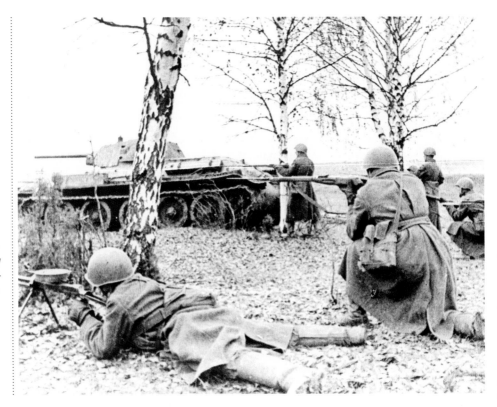

► Soviet infantry take cover near a T-34 tank. The T-34 was one of the most well-designed medium tanks of the entire war, and enabled the Red Army to take on the best of German armour. (NARA)

►► A shell explodes near a Red Army anti-tank team. The gun they are using is the 45mm M1937, which was based upon the German 37mm PaK 36. The M1937 had limited armour penetration, and was replaced in the anti-tank role by the M1942. (NARA)

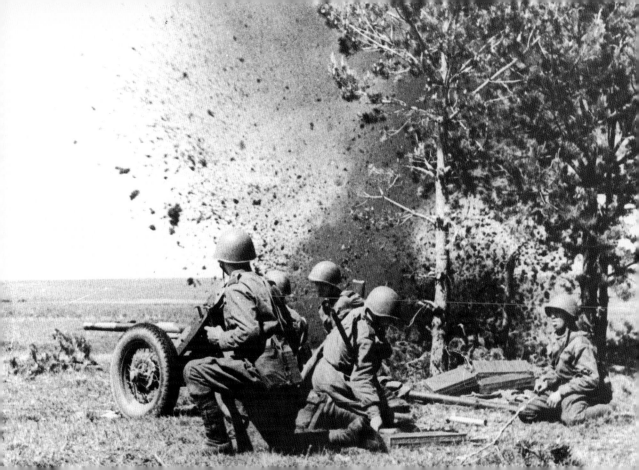

18 September. The *Luftwaffe* destroyed some 2,000 Red Air Force aircraft in a matter of days, for negligible losses. Tens of thousands of armoured vehicles were turned into blazing scrap.

The German war machine maintained what seemed to be unstoppable advances. By 15 September, Leningrad was cut off by Army Group North, and would endure a horrifying 900-day siege. The great Ukrainian cities of Kiev and Dnepropetrovsk fell into German hands. Most ominously for Stalin, by early December Army Group Centre was literally at the outer edges of Moscow itself.

Another mighty German victory seemed inevitable. But after its surging start, *Barbarossa*'s energy was starting to bleed away. The fighting was on a scale and intensity never previously encountered by the *Wehrmacht*, and casualties of men and vehicles were extremely heavy. The distances involved were also prodigious – 800 miles (1,287km) from the German frontier to Moscow – and supply lines were soon stretched to breaking point. Most significantly, the Soviet biannual (spring/autumn) rains (the *rasputitsa*) turned the battlefield into a quagmire, then an arctic winter froze unprepared vehicles

One man who had been walking outside for only a short distance without his woollen *Kofschutzer* or 'head saver' came into the sick bay. Both ears were white and frozen stiff.
– Heinrich Haape, on the first winter of the German campaign

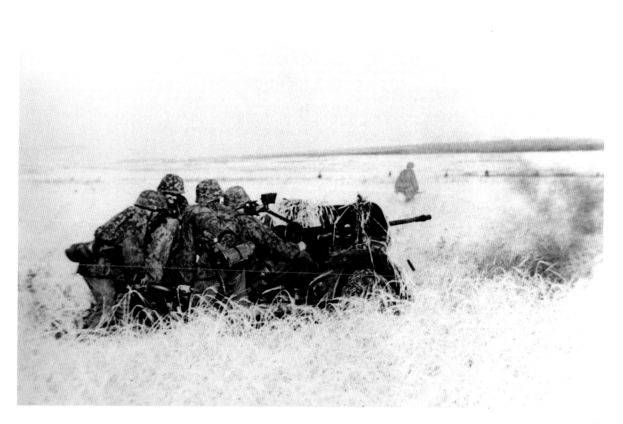

and weapons solid, and inflicted tens of thousands of frostbite and hypothermia casualties.

The Soviets were also counter-attacking. At first these counter-attacks were heavy, but localized. Then on 5/6 December, with the Germans struggling against the cruel weather, three Soviet fronts launched a general counter-offensive, utilizing fresh divisions that had previously been stationed in the east. The pushes were ultimately stopped by a desperate German defence, but critically they stamped out the immediate threat to Moscow and shook German confidence.

It soon became apparent to the Germans that the Eastern Front was to be a theatre unlike any other. Such was true particularly in the presence of several *Einsatzgruppen* ('Task Forces'), special *Schutzstaffel* (SS) formations that trawled in the wake of the German advance and conducted massive extermination operations against Jewish communities and other 'enemies of the state'. Little wonder the Soviet resistance was so ferocious.

As the winter gave way to spring in 1942, Hitler considered his next move. His focus now switched to the south. German defences had blunted several Soviet counter-attacks during the winter months,

Did you know?

In just two days in September 1941, SS units executed 33,771 Jewish men, women and children in a ravine known as Babi Yar, near Kiev, a small percentage of the 1.2 million murdered in such fashion.

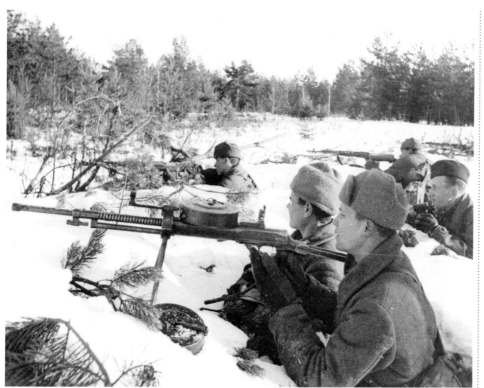

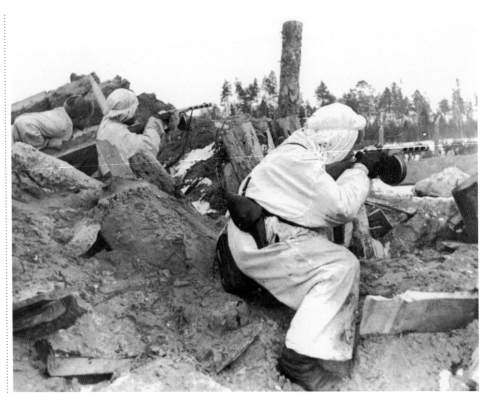

➤ By 1941, the Soviet Army had learnt hard lessons about fighting in sub-zero conditions during its Winter War with Finland in 1939–40. These soldiers are wearing winter camouflage outfits over quilted uniforms. (NARA)

➤➤ A Soviet infantry unit in action. The heavy machine gun in the background is the Maxim Model 1910, fitted to a cumbersome wheeled carriage, while the soldier in the foreground is armed with the more modern PPSh-41 submachine gun. (NARA)

and in May Generalfeldmarschall Erich von Manstein's 11th Army cleared the Kerch Peninsula in the Crimea, taking Sevastopol on the Black Sea the following month.

Hitler's major effort, however, was to be a deep thrust into the Caucasus, with the main aim being to capture the region's major oilfields, and to create a defensive line north of the Caucasus along the Don river. He formed his southern forces into two new army groups, A (the southernmost group) and B, and the offensive was launched on 28 June.

For much of the summer, the German advance of 1942 mirrored the power of earlier victories, as Russian resistance collapsed. The undercurrents were more troubling, however. Hitler was becoming increasingly prone to strategic tinkering, and on 13 July he added the conquest of

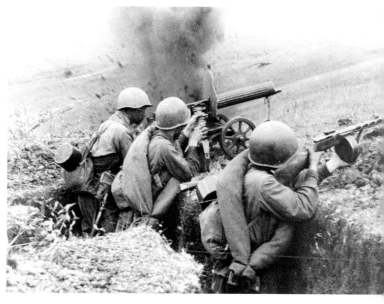

Stalingrad – the great city stretched along the Volga just beyond the bend of the Don – as a major objective for Army Group B. He also switched forces between the two

army groups, resulting in slow progress and wasted effort. Soviet resistance was starting to toughen up. In August, Army Group A's advance into the Caucasus was finally stopped by the Soviet Caucasus and Trans-Caucasus Fronts, with most of the Soviet oil facilities still out of reach. (The Germans did take the Maykop oilfields, but Soviet demolition work meant they were not able to make them operational.) The German 4th and 6th armies, meanwhile, closed up on Stalingrad by mid-September, and so began an urban battle of unparalleled ferocity.

It is difficult to overstate the horror that Stalingrad became. Hitler was obsessed with taking the city, with its highly symbolic name, and Stalin had an equal obsession with holding it, for the same reasons. During October and November, German artillery and air attacks reduced the city to a gaunt ruin, and German infantry took virtually the entire city, apart from a thin strip of dogged Soviet resistance on the banks of the Volga. This strip was enough for Stalin. He poured in hundreds of thousands of troops, and Stalingrad became the very antithesis of *Blitzkrieg* – a constant close-quarters battle in which hundreds would die taking individual buildings or factories. Then, on 19 November, the Soviets made a surprise counter-attack from positions north and south of the city, encircling and trapping

Did you know?

The Germans took a total of around 5.5 million Soviet POWs during the war, but at least 3.5 million died in captivity through starvation, mistreatment or execution.

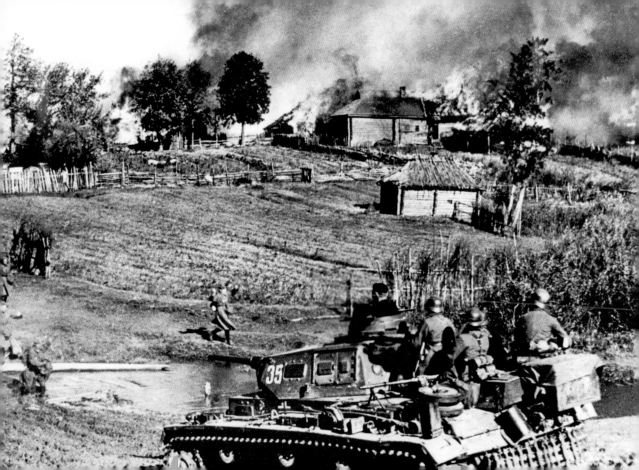

German forces by 23 November. Hitler forbade a breakout, and instead opted for an impractical attempt at air resupply. When that failed, Manstein's 11th Army attempted to open a corridor through to Stalingrad, but it was stopped short with heavy losses.

The entire German 6th Army and part of the 4th Army were now consigned to their fate. Some 100,000 fought to the death, despite being on the edge of starvation, and the remainder surrendered by 2 February 1943, most to die in Soviet captivity.

The destruction of an entire army was a catastrophic defeat for the *Wehrmacht*. It proved that it was not invincible in battle, and gave the Soviets a new-found optimism. In total, the battle for Stalingrad cost more than a million lives, but it proved to be the turning point in the war.

➤ *Weariness is etched deep into the faces of these German troops at Stalingrad in late 1942. The Battle of Stalingrad was decided primarily in small-unit actions, with submachine guns and hand grenades being the most effective weapons. (Cody Images)*

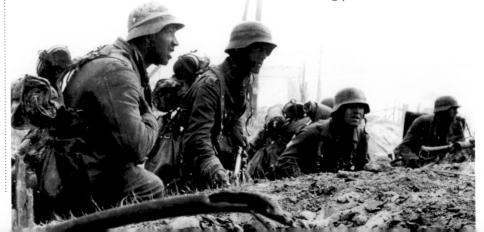

The fall of Stalingrad was just one of Hitler's major problems by early 1943. Not least of these was that he was now also at war with the United States, the most industrially powerful nation on earth, although it was the actions of an ally, Japan, that widened the war onto a truly global scale. (Germany, Italy and Japan had signed a mutual support alliance, the Tripartite Pact, in September 1940.)

Tensions between Japan and the United States had been building throughout the 1930s, as Japan began a programme of aggressive expansion in Manchuria, China and, in 1940, Indochina. In response, the United States imposed a tough blockade of raw materials into Japan. Threatened by the move, the Japanese government, led by fanatical nationalist Hideki Tojo as prime minister, looked to wider Pacific conquests

to solve their economic issues, and to build the empire they felt Japan deserved.

The Pacific War began on 7/8 December 1941 (events occurred either side of the date line), when Japanese aircraft carriers launched their notorious surprise attack at Pearl Harbor, Oahu, Hawaii. The aim of

In the aftermath of the Japanese attack on Pearl Harbor, the USS Maryland *stands above the hull of the USS* Oklahoma, *which capsized during the attack. Some 429 officers and men died aboard the* Oklahoma. *(NARA)*

> The whole forward half of the ship was a total wreck, through which tremendous oil fires now poured up their flames and great billows of smoke.
>
> – Walter Millis, describing the battleship Arizona during the Pearl Harbor attack

The destroyer USS Shaw explodes in a fireball at Pearl Harbor after being hit by multiple bombs. The source of the explosion was the forward ammunition magazine, but remarkably the ship was repaired and returned to service. (NARA)

the operation was to cripple the US Pacific Fleet, at least in the short term, rendering it incapable of responding while Japan built up a well-defended empire across South-East Asia and the South and Central Pacific. Two waves of Japanese dive-bombers and torpedo-bombers caught the Pacific Fleet by surprise during its Sunday routines, and in less than two hours sank six battleships (although four were later refloated), three destroyers, three light cruisers and four other vessels, and damaged numerous others. Yet despite the destruction, the Pacific Fleet's own carriers were out to sea at the time of the attack, ensuring that these critical vessels were still in the fight.

Pearl Harbor was just the beginning of a massive Japanese land campaign further east. On the same day as that attack took place, the Japanese 25th Army invaded Malaya from the north, and by 31 January all British forces had been

Did you know?

Shortly before the attack on Pearl Harbor, a US radar operator on Oahu reported a large number of aircraft approaching – the Japanese first wave. The report was dismissed as a flight of US Boeing B-17s, which were expected on a similar flight path.

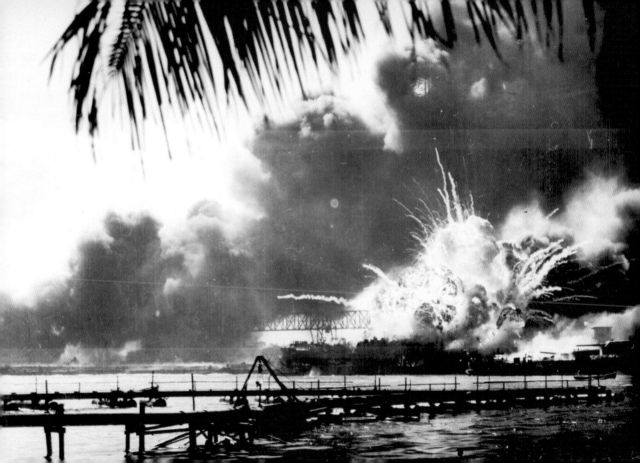

forced from mainland Malaya onto the island of Singapore. When that fell too, on 15 February 1942, 120,000 British soldiers went into captivity, and it was one of the worst defeats in British military history. Air attacks on the Philippines, a US commonwealth island, were followed by a sequence of amphibious invasions

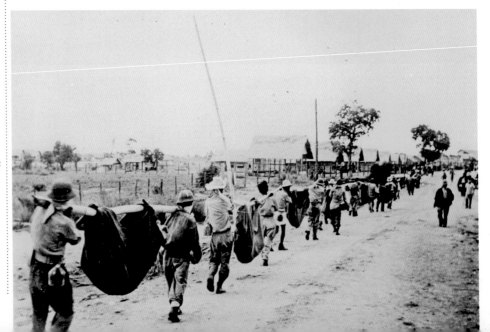

American prisoners on Bataan march off to a terrible future in May 1942. Many would not survive the journey to their camps, and here the prisoners use improvised litters to carry the wounded. (NARA)

Japanese paratroopers make a mass airborne deployment during the invasion of the Dutch East Indies in December 1941. The Japanese Army was an early pioneer of airborne operations. (IWM HU2767)

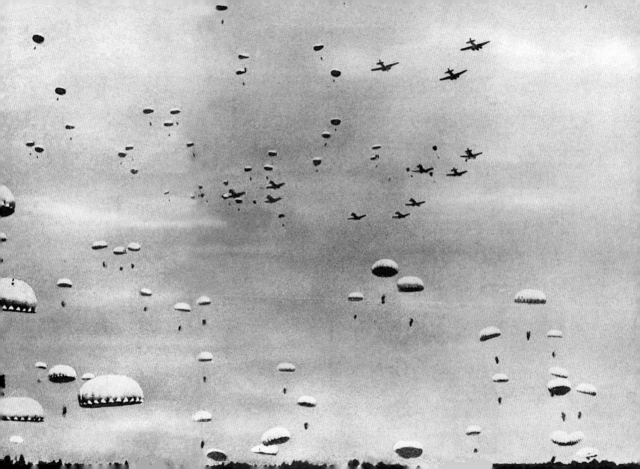

throughout December. US and Filipino troops, led by General Douglas MacArthur, put up a serious fight during a campaign that cost the Japanese heavy casualties, but by mid-May the Philippines had been added to the Japanese Empire.

The onslaught seemed unstoppable. Between 11 January and 8 March 1942, the Dutch East Indies were taken, and dozens of widely scattered Pacific islands were occupied and turned into fortified Japanese bases. British Burma also fell in the first three months of 1942. At sea, the Imperial Japanese Navy (IJN) were also ascendant, sinking the *Prince of Wales* and *Repulse*, two of Britain's most prestigious warships, on 10 December 1941, and destroying two Allied heavy and three light cruisers at the Battle of the Java Sea on 27 February.

At the height of its conquests, the Japanese Empire stretched from the Aleutian Islands in the northern Pacific to the Solomon Islands in the South Pacific, and from the borders of India in the west to the Marshall Islands in the East. The Japanese war had given Britain a new enemy to fight, and had brought the United States into the war on the side of the Allies. On 11 December 1941,

Did you know?

Despite the official US 'Germany first' policy, until late 1943 more US troops were deployed to the Pacific than to North Africa and the Mediterranean. It should also be remembered that Australia and New Zealand actually formed the largest Allied land army contingent in the Pacific theatre until 1944.

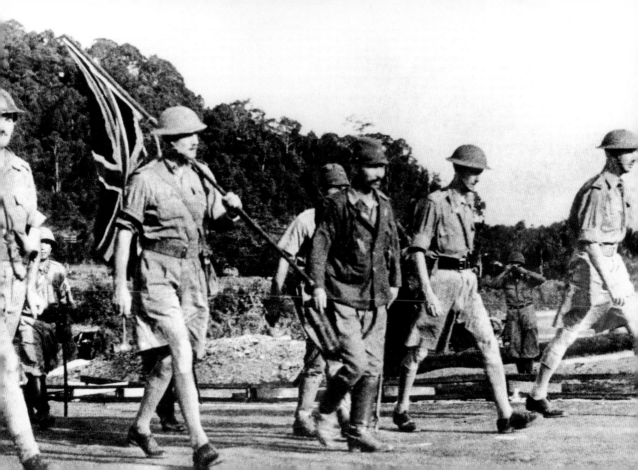

furthermore, Germany and Italy declared war on the United States. This was to be Hitler's greatest error, especially as the Allies agreed a 'Germany first' policy of tackling the Axis.

In 1942, however, the Japanese began to suffer their first defeats, as the US mobilized its manpower and its industrial machine for war. On 4 May 1942, a Japanese invasion fleet heading for Port Moresby in Papua was intercepted by the US Navy in the Coral Sea on 7 May. The subsequent carrier battle saw heavy losses on both sides, but the invasion was stopped. The Japanese then looked to take the US island of Midway, while at the same time luring surviving US carriers into a trap, in which they would be destroyed. In fact, forewarned by its intelligence service, the US Navy was waiting and ready. During the Battle of Midway on 4–7 June 1942, US dive-bombers caught Japanese carriers with their decks crowded with aircraft, which were in the process of being refuelled and rearmed. In a few shattering minutes, the Japanese lost three main fleet carriers, and a fourth carrier later in the day. Such a loss totally reoriented the balance of naval power in the Pacific to favour the Americans, and US shipbuilding would ensure that such dominance would only grow.

The terrifying scream of the dive-bombers reached me first, followed by the crashing explosion of a direct hit. There was a blinding flash and then a second explosion, much louder than the first.

– *Mitsuo Fuchida, describing bomb hits on the* Akagi *carrier at the Battle of Midway*

In mid-1942, the United States and its allies built up strength sufficient to go on the offensive. From the US perspective, the entire Pacific theatre was divided into two spheres of influence. The Southwest Pacific region – essentially everything west of a line drawn from the Solomons to the Philippines – was under the command of General MacArthur (he had escaped from the fall of the Philippines), while the rest of the Pacific was under the authority of Admiral Chester Nimitz, the commander-in-chief of the Pacific Fleet. The first offensive objective was the Solomon Islands; the 1st Marine Division landed on Guadalcanal and Tulagi on 7/8 August. The latter was secured, but the former, with its vital airbase known as Henderson Field to the US troops, became the location for a grinding, close-quarters six-month

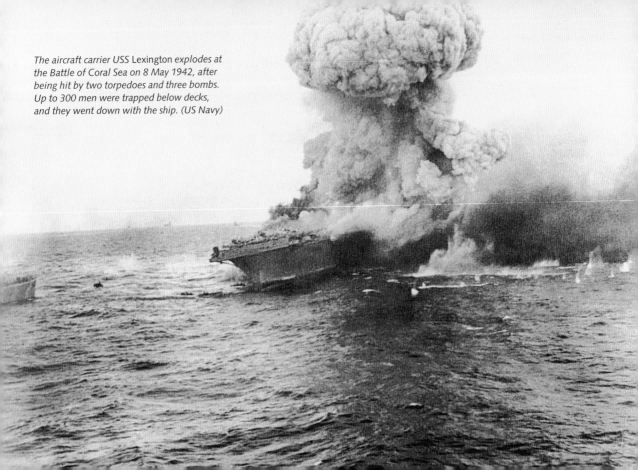

The aircraft carrier USS Lexington explodes at the Battle of Coral Sea on 8 May 1942, after being hit by two torpedoes and three bombs. Up to 300 men were trapped below decks, and they went down with the ship. (US Navy)

Did you know?

In March 1942, on the Philippines, some 1,000 US troops were being admitted to hospital for malaria every single day. Until late in the war, disease inflicted more casualties upon the Allies in the Pacific than combat.

war of attrition. Numerous major naval battles were fought around the Solomons, and both sides suffered greatly, but by November 1942 Guadalcanal had become a secure US foothold in the island chain.

The second half of 1942 also saw intensive fighting in New Guinea. On 21 July, some 16,000 troops of the Japanese 18th Army landed around Buna on north-east Papua, and began an overland advance across the

Owen Stanley mountain range towards Port Moresby in the west. They advanced against Australian and US resistance to within 30 miles (48km) of their objective before they finally ground to a halt, critically weakened by disease, starvation and battle

▼ *The Battle of Midway was a crucial point in the Pacific War, in which the naval advantage passed to the United States following the destruction of four Japanese aircraft carriers. (Derrick Wright, Pacific War)*

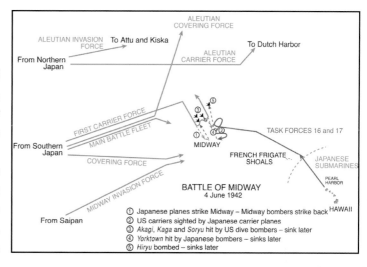

BATTLE OF MIDWAY
4 June 1942

① Japanese planes strike Midway – Midway bombers strike back
② US carriers sighted by Japanese carrier planes
③ *Akagi, Kaga* and *Soryu* hit by US dive bombers – sink later
④ *Yorktown* hit by Japanese bombers – sinks later
⑤ *Hiryu* bombed – sinks later

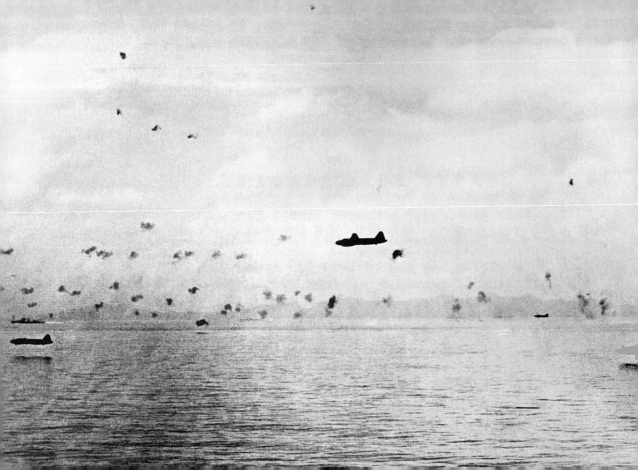

◄◄ *Japanese Mitsubishi G4M 'Betty' bombers run through a cloud of anti-aircraft fire as they attack US shipping off Guadalcanal. As the Pacific War progressed, the Japanese Air Force suffered a catastrophic loss of air supremacy. (USMC)*

◄ *Japanese bombers strike at US positions on Henderson Field on Guadalcanal. The airfield was the site of a prolonged and violent struggle between the Japanese forces and the American occupiers in the summer and autumn of 1942. (Marine Corps University Archives)*

casualties. The Allied troops then put the advance into reverse, forcing it all the way back to Buna in a campaign of legendary punishment on body and mind. In January 1943, Buna itself fell. Now lay open the possibility of Allied forces on New Guinea working with those in the Solomons to trap and take the major Japanese supply port of Rabaul on the eastern tip of New Britain.

By the beginning of 1943, the Allies had seriously weakened Japanese naval power and were making their first inroads into the fledgling Japanese Empire. Now the Allied military planners began to look for routes of advance to the Japanese homeland itself.

◄ *Another Japanese victory. Here Japanese infantry cheer with the fall of Rangoon in March 1942. The battle for Burma, however, would continue for more than three years and involve US, Chinese, British and Commonwealth forces. (Cody Images)*

The Italian campaign was meant to be, in Churchill's famous words, a strike through the 'soft underbelly' of Europe. Not only was it intended to appease the Soviets – with the fall of North Africa, Italy offered the prospect of drawing away German forces from the Eastern Front – but it was also designed to distract the Germans away from the forthcoming invasion of occupied France. As it turned out, the Italian campaign became one of the most bloody and badly managed Allied theatres, and has hence attracted lasting controversy.

Prior to invading mainland Italy, the Anglo-American 15th Army Group first took Sicily in July 1943. Operation *Husky*, one of the largest amphibious invasions of all time, secured the island by 17 July, but also failed to stop many of the German troops evacuating to mainland Italy. Italy itself was invaded on 3 September 1943, when the British 8th Army (Montgomery)

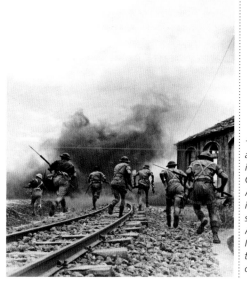

◄ *British troops advance along a railway track in Sicily. Codenamed Operation* Husky, *the Allied invasion of Sicily in 1943 was the stepping stone between North Africa and mainland Italy. In two months of fighting, the Allies suffered 22,000 casualties. (Cody Images)*

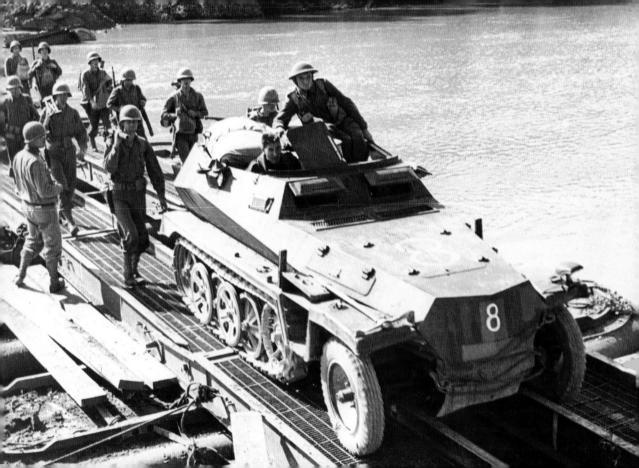

crossed the Straits of Messina and secured a beachhead at Reggio di Calabria. On 9 September, the US 5th Army (Lieutenant-General Mark Clark) went ashore some 200 miles (320km) further up the east coast at Salerno. (There were also further British invasions at Taranto.) Just the day before, Italy, seeing the writing on the wall, signed an unconditional surrender with the Allies, the Italian government having ousted Mussolini the previous July.

Italy's mountainous terrain, and adverse autumn and winter climates, made it a country designed to favour a defender. So it proved. The German 10th and 14th armies made the Allies pay for almost every metre of advance up the Italian peninsula, while Allied commanders showed little ability to coordinate their efforts across the broad front.

Did you know?

The Italian dictator, Mussolini, was captured by Italian communist partisans on 27 April 1945. The next day he was executed, along with his mistress Clara Petacci, and their bodies were subsequently strung up and abused by a crowd outside a Milanese petrol station.

Here was a war of attrition, pure and simple, and this was nowhere better exemplified than during the battles to break the German 'Gustav Line' defences stretching across Italy south of Rome. It took four major battles and 55,000 casualties to defeat the defence of Cassino alone, with its famous monastery atop Monte Cassino, despite the Allies using their overwhelming

◄ US troops cross a pontoon bridge over the Volturno River in October 1943. They are accompanied by two British soldiers, who are riding aboard a captured German SdKfz 250 half-track. (Cody Images)

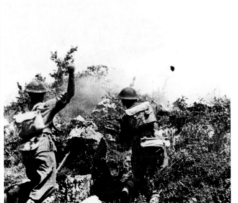

air power and artillery. A US amphibious landing north of the Gustav Line, at Anzio from 22 January 1944, did not break the grind, and instead resulted in 50,000 US troops trapped and fighting for their lives. The final breakthrough on the Gustav Line relieved the siege at Anzio, but Clark's diversion to secure Rome, which fell on 5 June, meant that the German 10th Army slipped away to fight another day.

It is not easy to convey. This kind of fighting has little coherence, no design that is easy to follow. For the New Zealanders it was a mosaic of grim little fights over small distances.
– *Fred Majdalany, on the battle for Cassino*

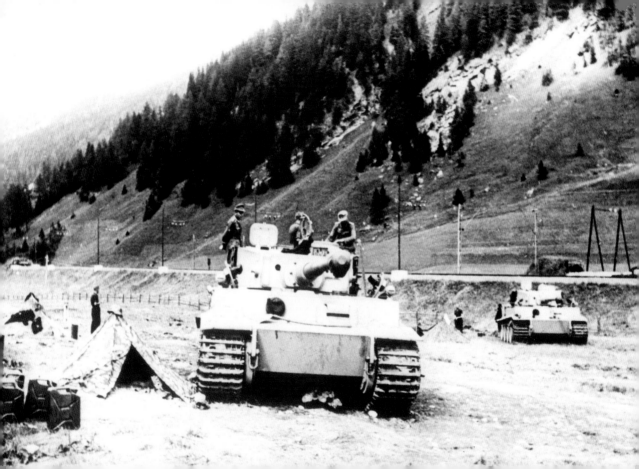

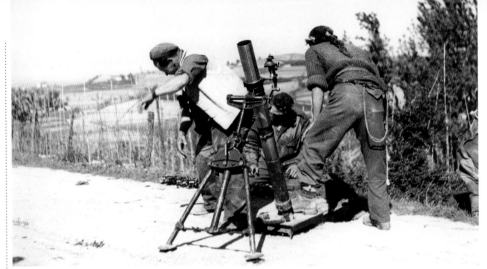

▶ *A British SAS Special Forces team fire a mortar somewhere in Italy. Founded in 1942, the SAS also conducted high-risk operations in North Africa and Western Europe, pioneering fast raiding tactics. (Cody Images)*

From June 1944, the lion's share of Allied energy was going into the war on the Western Front. The forces on the Italian front, therefore, simply continued to inch their way through successive German defensive lines, but with a better momentum as the Germans finally began to weaken after months of fighting. The 'Gothic Line' in the Apennine mountains was breached in September 1944, but fighting continued until 2 May 1945, on which date the battered remnants of German Army Group C (the umbrella for the 10th and 14th armies) finally surrendered in the far north of Italy.

Although Britain had fought off the prospect of a German invasion in 1940, the country nonetheless remained isolated off the coast of occupied Europe. Yet to sustain its war effort, economy and population, Britain was utterly dependent on maritime imports, particularly from across the Atlantic. Recognizing this fact, Admiral Karl Dönitz, commander of Germany's U-boat submarine fleet, set about trying to sever this lifeline. Such operations were made easier with the fall of France, as the U-boats could now deploy straightforwardly into the Atlantic from bases along the French coastline, as well as those in occupied Norway.

The stakes of the Battle of the Atlantic were extremely high. Winston Churchill confessed after the war that 'the only thing that ever really frightened me during the war was the U-boats'. Using 'wolf pack' tactics, the U-boats would wait on station in the Atlantic, detecting and attacking convoys in large, radio-coordinated groups. One convoy, sailing in October 1940, lost twenty-one out of thirty vessels during its

▼ *A Type VIIC U-boat pulls into harbour after operations, to be greeted by a Kriegsmarine band. If refuelled and replenished at sea, U-boats could spend weeks, even months, away from their land bases. (Cody Images)*

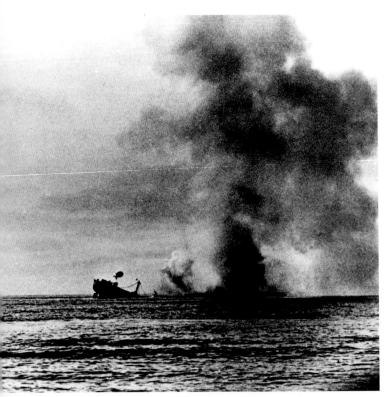

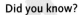

Did you know?

The most prolific model of U-boat was the Type VII. The Type VIIC version could dive to a maximum depth of 722ft (220m), had a crew of up to 52 men, and carried fourteen torpedoes as its primary armament.

voyage. In total, U-boats sank 2.1 million tons of Allied shipping in 1941, an average of 175,000 tons each month. Such was the level of success that the U-boat crews referred to the period June 1941–February 1941 as the 'Happy Time'. The second happy time came the following winter, when an initially complacent United States joined the war and U-boats sank a million tons of shipping in US waters in May and

June 1942 alone. Indeed, 1942 was the *annus horribilis* of the U-boat war for the Allies, in which they lost 6 million tons of vessels to the German submariners.

The Allied defence against the U-boats was a mixture of depth-charge armed escort vessels, maritime patrol aircraft, ULTRA intelligence derived from breaking German naval codes and the convoy system itself. Mighty US shipbuilding efforts also began to launch more merchant vessels than the U-boats could possibly sink. In 1941 US shipyards launched 1.03 million gross tons of such ships; in 1943 the figure was 11.5 million gross tons. Moreover, anti-submarine tactics and technologies improved dramatically. Shipboard sonar detection equipment and High-Frequency Direction-Finding (HF/DF) sets, plus aircraft-mounted short-wave radar, meant the U-boats became easier to detect, while improved depth charges and other weaponry increased the lethality of escorts and maritime aircraft. By mid-1943, the 'air gap' – the zone of the central Atlantic not covered by land-based air escort – had been closed by aircraft such as the Very-Long-Range (VLR) Liberator. Combined with improved tactics and the continual efforts of codebreakers, the Allies began to kill U-boats in large numbers – eighty-seven

> Everyone has a look through the periscope. The fine ship before us is sinking into the sea. Emotion overcomes us. The demonic madness of destruction that becomes law the moment a war breaks out has us in its grip.
>
> – *U-boat captain Heinz Schaeffer*

◄ *An Allied ship, torpedoed by a U-boat, slips beneath the waves north of Norway in July 1942. In such freezing northern waters, any survivors who went into the water succumbed to hypothermia rapidly if not rescued. (Cody Images)*

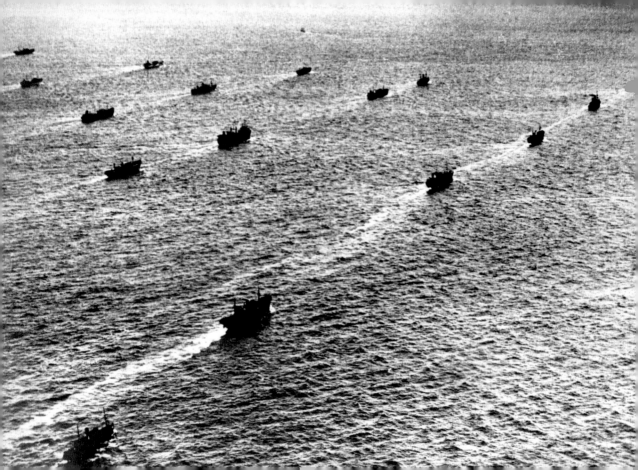

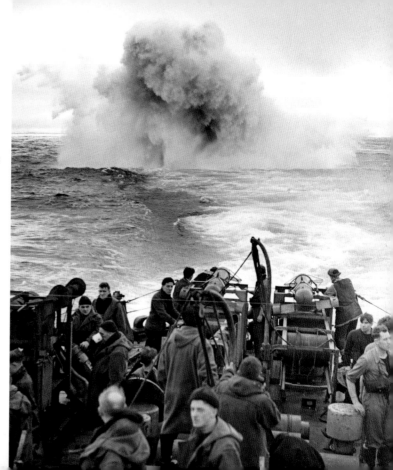

Did you know?

Being a U-boat crewman became the most dangerous job in the *Wehrmacht*, with the highest probabilities of death in action. By the end of 1943 the casualty rate was running at around 75 per cent.

◀ At first glance the convoy system appeared to present the enemy with an easy target. Yet the convoys, developed by the British, actually increased the statistical likelihood of numerous ships crossing the Atlantic unscathed. *(Cody Images)*

▶ The crew of the sloop HMS Starling *rolls depth charges off the stern of the ship as they attempt to destroy U-boats. The vessel participated in the destruction of no less than fourteen U-boats in 1943 and 1944. (Cody Images)*

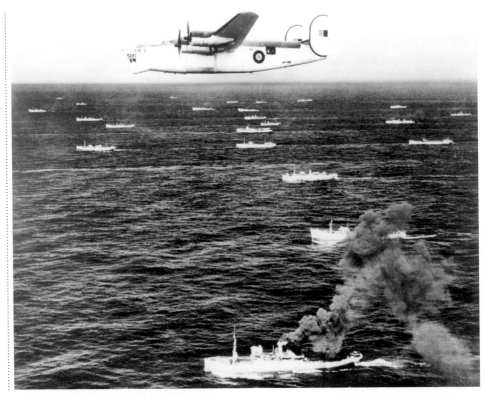

➤ An RAF Liberator maritime patrol aircraft flies over an Allied convoy. Such aircraft became one of the chief reasons for the Allied victory against the U-boats, particularly once Very-Long-Range (VLR) aircraft closed the 'air gap' in the middle of the Atlantic. (Cody Images)

➤➤ St Nazaire burns as US bombers unleash their payloads over the French port, which was home to the 6th and 7th U-boat flotillas. Most Allied bombs, however, could not penetrate the U-boats' hardened storage pens. (Cody Images)

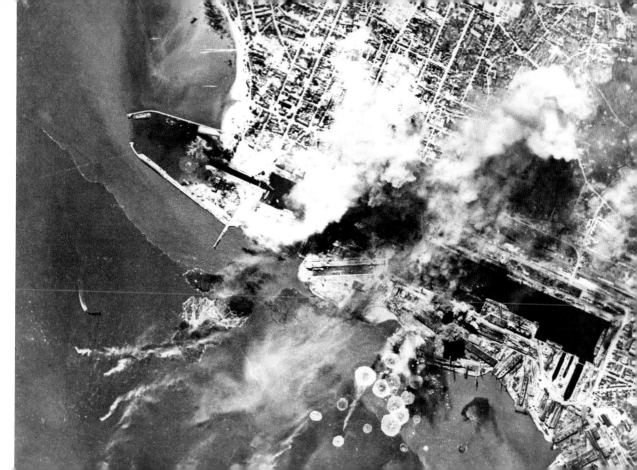

U-boats in the Atlantic, Arctic and Baltic in 1942, but 237 in 1943 and 242 in 1944.

The Allied invasion of France in June 1944 signalled the effective end of the U-boat campaign in the Atlantic, as the *Kriegsmarine* began to lose its Western European bases. For the Allies, the timing was fortuitous, as in the later years of the war U-boats and their weaponry reached new levels of sophistication, including acoustic homing torpedoes and vessels capable of staying submerged while recharging their engines (U-boats were at their most vulnerable while surfaced). But the battle for the Atlantic was not just a military campaign – 36,000 merchant navy sailors also died in the bitter waters, and tens of thousands more endured U-boat threats and brutal seas on a weekly basis.

The concept of strategic bombing – using long-range bombers to destroy an enemy's economic, social and military means of resistance – dated back to the last years of World War I. During the inter-war years it took shape theoretically if not practically, and in Britain led to the formation of RAF Bomber Command in 1936. Germany's air force was far more tactical in nature, with an emphasis on two-engine medium bomber types, but both Britain and the United States created the requisite four-engine heavy bombers required for long-range strategic bombing. Representative types included the Boeing B-17 Flying Fortress and Consolidated B-24 Liberator (US), and the Short Stirling and Avro Lancaster (UK).

Strategic bombing against Germany during World War II was a politically and ethically complex affair, one that remains controversial to this day. The name most associated with the British side of the campaign was the Air Officer Commanding-in-Chief (AOC-in-C) of Bomber Command (from February 1942), Air Marshal Arthur Harris. Strategic bombing against Germany predated Harris' takeover, but Harris expanded the efforts to a punishing scale,

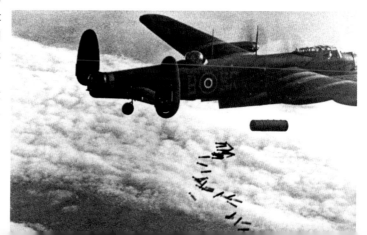

▼ *An RAF Bomber Command Lancaster unleashes its payload over Duisburg on 15 October 1944. The large high-explosive (HE) 'cookie' bomb is accompanied by dozens of small incendiary devices, the HE bomb blowing apart buildings and exposing the interiors to the incendiaries. (Cody Images)*

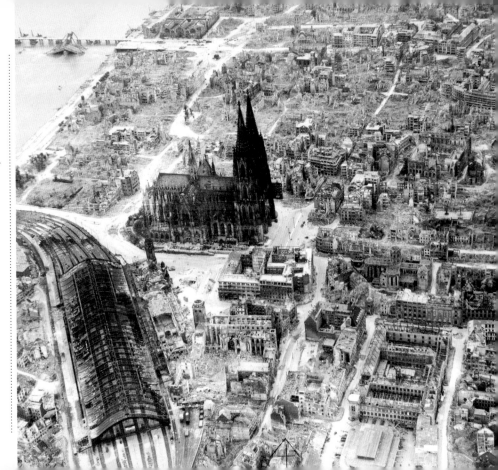

➤ Many German cities were reduced to nothing more than ruins by the Allied strategic bombing offensive. Here we see the wreckage that was Cologne by 1945, although the city's great cathedral was apparently spared destruction. (Cody Images)

➤➤ A US Boeing B-17 bomber seen during an attack on the Focke-Wulf aviation plant at Marienburg in 1943. The daylight raid was extremely costly for the US Army Air Force, with some eighty aircraft and 800 men lost. (NARA)

believing that air power alone was capable of bringing Germany to its knees.

Bomber Command came to specialize in night-time 'area bombing' (striking at broad industrial and civic areas rather than specific localized targets); darkness provided protection in the absence of fighter escort, while area bombing compensated for the serious inaccuracies of high-altitude attacks. Harris unleashed hell upon Germany's towns and cities, including the first 1,000-bomber raid over Cologne on 30/31 May 1942, and the near destruction of Hamburg in July 1943, which alone killed more than 40,000 people. Berlin was also hit in sixteen major raids between November 1943 and March 1944, destroying large parts of the city but costing the British 492 aircraft (more than 2,700 were lost or damaged in total during this period).

In 1943, the US Army Air Force (USAAF) also began to add its substantial weight to the strategic bombing campaign, in the form of the 8th USAAF operating from the

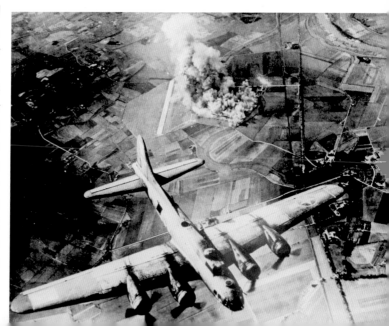

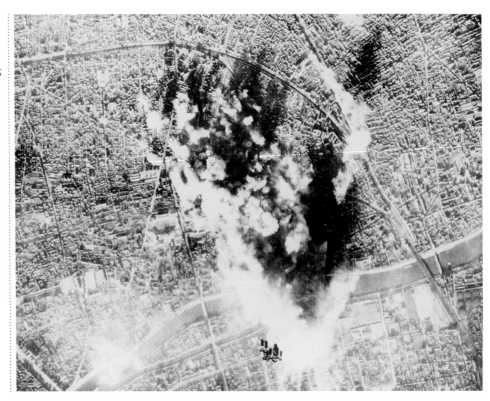

➤ Occupied France also came in for heavy bombing from US and British air forces. Here bombs fall down from US aircraft on 31 December 1943, the targets being a ball-bearing plant and aircraft engine factory near Paris. (NARA)

UK and the 15th USAAF in Italy. Despite the grave warnings issued by the British about flying in daylight against German fighter defences, the USAAF opted for day raids, arguing for its ability to deliver more decisive 'precision' bombing. Devastating losses during raids over Schweinfurt in October 1943, however, forced it to rethink its tactics. Carl Spaatz, head of the 8th USAAF, did not switch away from day bombing, but instead developed long-range Mustang fighter escorts that could accompany the bombers through the full range of the mission.

Spaatz's innovation proved to be one of the most decisive of the strategic bombing campaign, for it eventually forced unacceptable levels of attrition on the *Luftwaffe* as it battled to defend the Reich. Otherwise, the results of the Allied air

Trees three feet thick were broken off or uprooted, human beings were thrown to the ground or flung alive into the flames by winds which exceeded a hundred and fifty miles an hour.
– A German secret report on the effects of Allied bombing

campaign are open to debate. By itself, it did not subjugate Germany, although up to a million German citizens were killed in air raids, war production increased significantly until the very last months of the war. Raids such as that over Dresden between 13 and 15 February 1945 – a resulting firestorm killed more than 25,000 civilians – have also led many historians to brand the strategic bombing campaign as immoral.

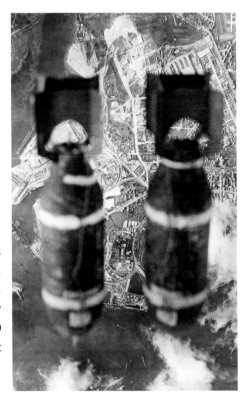

A pair of British bombs drop over a U-boat base along the French coast. Although the raid here is conducted by daylight, the RAF traditionally bombed targets in Germany itself at night, relying on the cover provided by darkness instead of a fighter escort. (Cody Images)

Did you know?
A 'firestorm' effect was created when numerous urban fires coalesced into a single, all-consuming conflagration, causing and fuelled by hurricane force winds and generating temperatures of up to 1,472°F (800°C).

Yet the Allied bombers undoubtedly had a severe impact on German oil production, transportation, morale and manufacturing, and diverted broad military resources away from the frontlines. The cost of 100,000 Allied aircrew, therefore, was almost certainly not in vain.

By mid-1943, the Soviets were making good, if exceptionally costly, progress against the Germans on the Eastern Front. It was evident to the Allies, however, that the key to bringing the war to a conclusion was the opening of a second front in Western Europe. By such a means, the Allies could trap Hitler's forces in a crushing two-front war, and also liberate millions of people from Nazi rule.

Preparations for the invasion began in 1943, and Allied intentions were largely hidden from the Germans in a deception campaign as brilliant as it was ambitious.

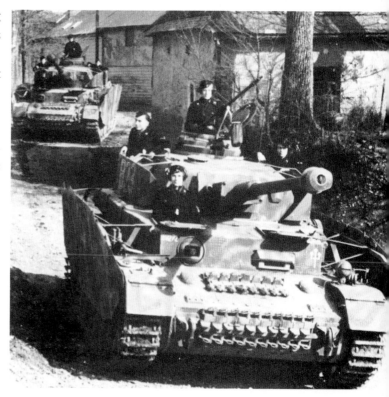

▶ *Tanks of the 2nd Panzer Division roll through France in 1944. German forces in the West were unable to concentrate their armour against the Allied landings quickly enough, partly on account of the delays imposed by enemy ground-attack aircraft. (Cody Images)*

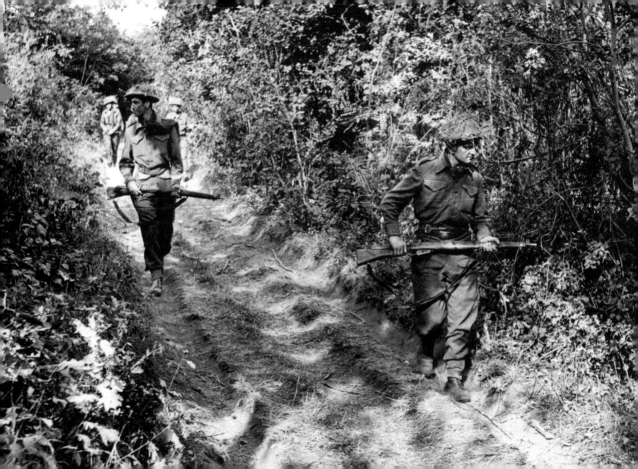

The efforts obviously worked (one of its effects was to convince the Germans that the landings were most likely to come in the Pas de Calais), for on 6 June 1944 the equivalent of ten divisions of Allied troops were landed on the beaches of Normandy, largely against unprepared defenders.

Operation *Overlord*, as the invasion of France was known, was a truly epic undertaking. It was opened by major, albeit confused, deployments of airborne troops behind enemy lines in the early hours of the morning, and was followed by amphibious landings of 175,000 Canadian, British and American soldiers from 4,000 ships. Although US forces took very heavy casualties at one of their landing beaches, codenamed 'Omaha', overall dead and injured figures on D-Day were lighter than expected, and by the end of 6 June the Allies had established a beachhead in occupied France.

The response from German Army Group West, under the overall command of Generalfeldmarschall Gerd von Rundstedt, was initially confused, but toughened significantly over the following days as reinforcements were channelled towards the front from inland and southern France. (This movement was itself made harrowing

◀ British soldiers patrol with great care through the bocage country of Normandy. Ambushes were all too common in such narrow lanes, and at one point losses of British officers in Normandy exceeded the rates reached during the great battles of World War I. (Cody Images)

Did you know?

Some 8,500 Allied aircraft were deployed during D-Day, quickly establishing air superiority. Although they provided vital air cover, Allied bombers also inflicted thousands of French deaths as they bombed French cities such as Caen.

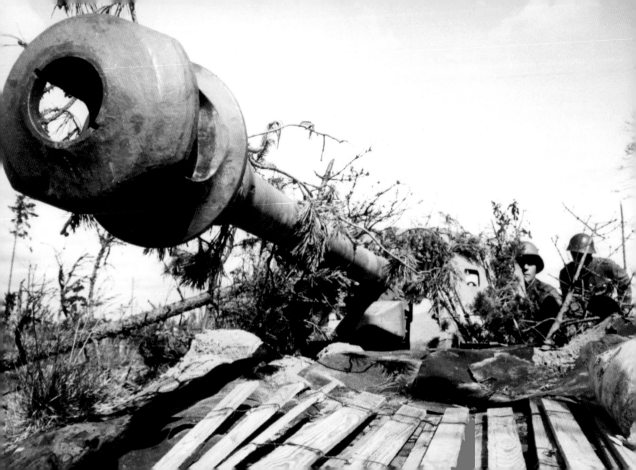

for the Germans by constant Allied fighter-bomber attacks, and sabotage from the French Resistance.) The *bocage* terrain of Normandy, with its narrow country lanes, thick hedgerows and woodlands, was ideal defensive terrain, and losses of Allied troops and tanks were substantial – 122,000 men were killed or wounded in the first two months of operations in Normandy. Yet those two months bore gradual, arduous fruit. The cities of Cherbourg (a vital port), St Lô and Caen were taken, the Cotentin peninsula cleared and, more importantly, the Allies had brought in more than a million troops and 150,000 vehicles.

Although the Allies paid heavily for their advances, their overwhelming material muscle (largely courtesy of the Americans), particularly in tanks, aircraft and artillery, unleashed appalling destruction upon the Germans, who took 60,000 casualties alone in the battle for the 'Falaise pocket' in mid-August, and began a steady advance to the north-east. Paris was liberated by 25 August, and the British and American army groups pushed through northern

◄ *A close-up view down the business end of a German 75mm PaK 40 anti-tank gun. Such guns inflicted heavy losses upon British, Canadian and US armour in the narrow lanes and open fields of Normandy. (Cody Images)*

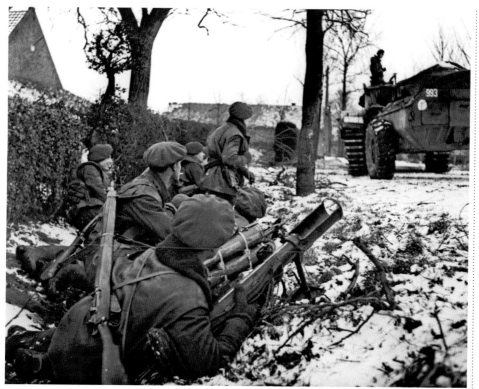

◄◄ *German troops move cautiously at Arnhem, during fighting against the British airborne forces of Operation* Market Garden *in September 1944. Although an Axis victory, the battle still cost German troops more than 13,000 casualties. (Cody Images)*

◄ *British troops in the Netherlands during the winter of 1944–45 man a trench position. The man in the foreground has a PIAT anti-tank launcher, a crude device only effective at short ranges. (Cody Images)*

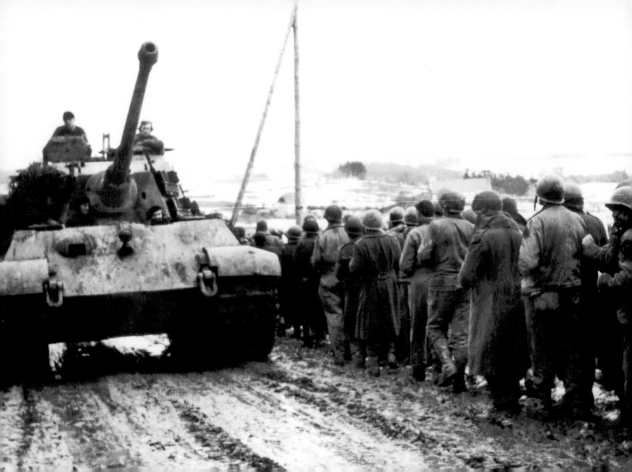

France, Belgium and the south-eastern Netherlands, looking to cross the Rhine into Germany itself.

It is testimony to the quality of the *Wehrmacht* that the Allied advance was contested so convincingly. In September 1944, for example, Operation *Market Garden*, a British airborne attempt to expedite a Rhine crossing at the Dutch city of Arnhem, was decisively crushed and resulted in little more than 7,000 British dead, wounded or captured. The biggest shock of all, however, came on 16 December, when twenty-four German divisions launched a full-scale counter-attack against the US 1st Army in the Ardennes in Belgium. Conceived by Hitler, the operation aimed to advance through Belgium and capture the Allied supply port at Antwerp, while also splitting British and US forces. The initial advance was strong, with penetrations of up to 60 miles (97km), but eventually Allied firepower and German fuel shortages stopped the motion, and eventually crushed it with further harrowing losses to an already weakened German Army.

By early 1945, the Allies had closed up on the Rhine. The first crossing came on 7 March by men of the US 1st Army, and further

◄ *In the Ardennes in late 1944, a German Tiger II tank passes a stream of US Army prisoners. Although the Ardennes offensive was a shock to the Allied system so late in the war, once it was suppressed it did little but hasten the end of German resistance. (Cody Images)*

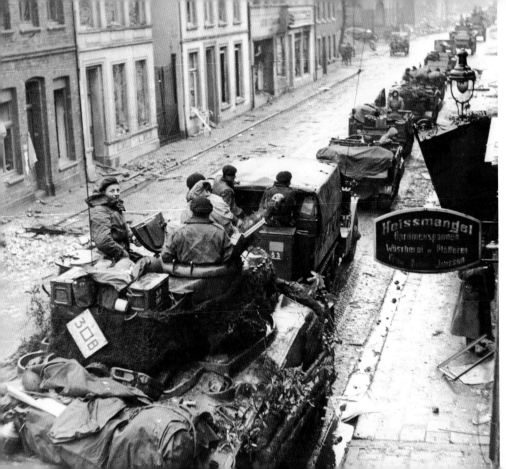

◄ UK forces advance into a German city in 1945. Most German towns and cities were reduced to shattered ruins by the time the war passed through them, although German citizens in the West were generally treated civilly by the Allied troops. (Cody Images)

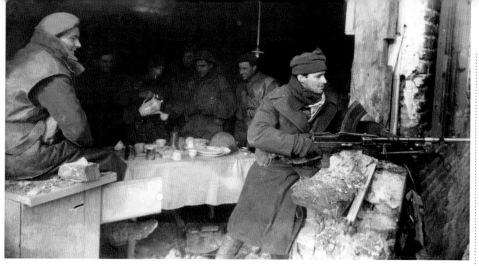

◄ British soldiers enjoy a cup of tea in a shattered building in Germany, January 1945. At the 'entrance' to the building, a trooper stands guard with a Bren Gun; the standard light machine gun of the British Army during the conflict. (Cody Images)

The 5th Battalion had gone but its dead remained, littered about the field, staring up at the sky with the flies buzzing over them and their big boots poking up in the long grass.

– Alexander Baron, describing a Normandy battlefield

crossings were made later in the month. The advance into Germany began. Yet those Western Allied troops who hoped to take Berlin would be disappointed. Eisenhower set the limits of the western advance to the River Elbe, which was reached by late April. The prize of the German capital would, by agreement, go to the Soviets.

Following their victory at Stalingrad, Soviet forces in the south continued their drive to the west, cutting off and trapping most of Army Group A in the Caucasus, recapturing Kharkov, and inflicting tens of thousands more casualties upon the *Wehrmacht*. There were Soviet reverses, however. A German counter-attack drove

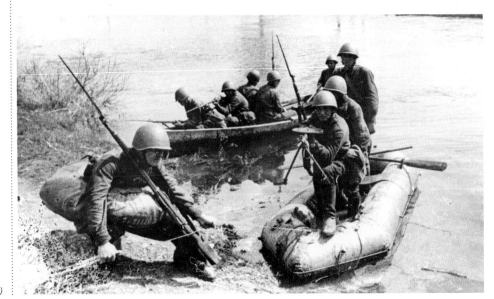

➤ *A Red Army unit makes a river crossing in the summer of 1943. By 1943 the Soviets had become more tactically confident, and they had absorbed the small-unit lessons of the last two years of fighting. (NARA)*

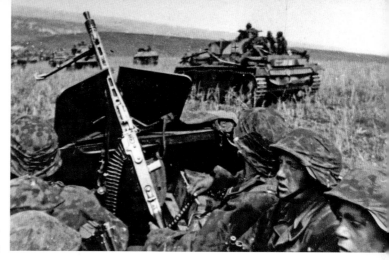

Did you know?

In 1943, the Germans produced 12,063 tanks and self-propelled guns. The Soviets, by contrast, manufactured 24,089 armoured vehicles during the same year.

the Red Army back in several sectors, including around Kharkov, which fell once again into German hands.

The frontline in the south had stabilized by late March. One distinctive feature of its contours was a large Soviet salient around the city of Kursk, occupied by the Central and Voronezh Fronts. It was precisely this salient that Hitler decided to cut out with Operation *Citadel*, and what would become arguably the largest land battles in history.

The offensive began on 4 July, as the German 9th Army from the north and 4th Panzer Army from the south bit down hard into the neck of the salient. Soviet forces had been preparing for such a campaign for two months, and in consequence 2 million men, 6,000 tanks and 4,000 aircraft locked in apocalyptic battle.

▲ *A German Panzergrenadier division moves into action at the Battle of Kursk in the summer of 1943. The troops in the foreground ride in a half-track, with an MG42 machine gun mounted in a shield at the front for providing support fire. (Cody Images)*

➤ A Soviet tank crew cook up some food during the advance into Germany, spring 1945. Note their US-made M4A2 Sherman tank, delivered to Red Army service via the Lend-Lease scheme. (NARA)

> The flower of the German Army had fallen in the Battle of Kursk, where our troops attacked with a desperate determination to conquer or die.
>
> *– General Friedrich von Mellenthin*

The Battle of Kursk ran for nearly two months, although the German offensive essentially ceased within two weeks. The Soviets undoubtedly suffered greater losses – about 800,000 casualties and 6,000 armoured vehicles destroyed – but their manpower and industrial production was better able to cope than the Germans, who lost perhaps 200,000 men and more than 700 armoured vehicles. (Accurate figures for casualties and losses at the Battle of Kursk are notoriously hard to come by.) Kursk was arguably a more important battle than Stalingrad. While Stalingrad had signalled Germany's first major defeat in the east, Kursk was Germany's last major offensive effort. By the battle's end, the German armed forces were a shadow of their former selves, both in terms of manpower, morale and material, and they began what would be a long, dreadful retreat back to the Reich.

Did you know?

By 1943, Soviet forces had made major advances at a tactical level, improving their use of minefields, anti-tank weapons, small-unit leadership and intelligence. Volumes of manpower and equipment alone are not the sole reason for their victories later in the war.

THE END IN GERMANY

A brief summary of the last two years of fighting on the Eastern Front in no way does justice to the scale and ferocity of the events. The Germans proved equally vigorous in defence as they had been in offence, and thousands of Soviet troops spilt their blood for every mile gained. Yet the German ability to hold up the Soviet Army was undoubtedly crumbling. Major Soviet offensives in the second half of 1943 pushed back the entire frontline between Smolensk and the Black Sea, retaking key cities such as Kiev and crossing the Dnieper River. In the far north, Leningrad was finally relieved at the end of January 1944, after around a million of its inhabitants had died, mostly from starvation. By the spring of 1944, three German army groups had been driven from the Ukraine, and in the

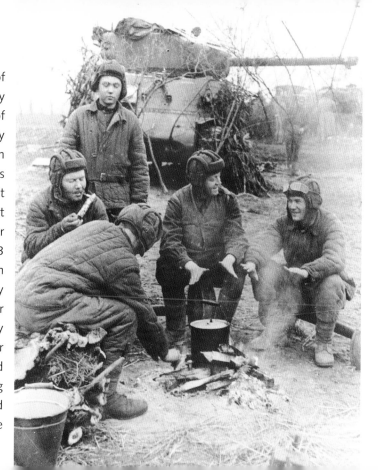

following June–August Army Group Centre was almost entirely destroyed by a vast offensive, Operation *Bagration*, which also cleared German forces from Belorussia and eastern Poland.

The combined result of these offensives was that by the end of August 1944, German forces had been driven from Soviet territory into Eastern Europe and the Balkans, where the fighting raged with undiminished intensity. Red Army soldiers were at the gates of Warsaw and the borders of East Prussia. By mid-October the Germans had also been largely cleared from the Baltic States. Hitler aided the German collapse with a feverish interference in all major strategic decisions, overriding and sacking experienced generals on

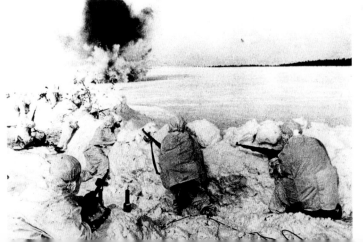

Did you know?

Coordinated sabotage actions by Soviet partisans at the beginning of Operation *Bagration* targeted the rail networks supplying the German Army Group Centre. In two nights alone, 19–20 June 1944, the partisans detonated 10,500 explosive charges.

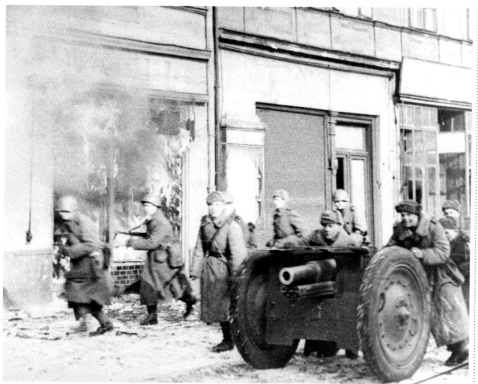

The last months of the battle for Germany in the east consisted of numerous urban combats. This unit has a 76mm M1927/39 regimental gun, which would be used to destroy buildings over open sights at point blank range. (NARA)

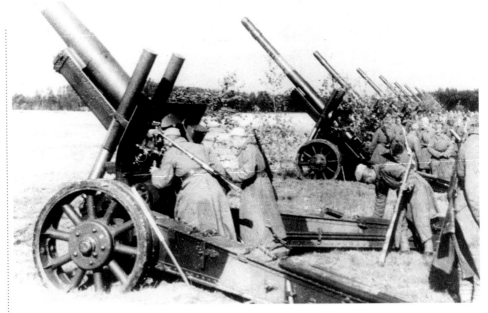

By 1945, the Red Army had huge volumes of artillery firepower, as suggested here in this line of ML-20 152mm gun-howitzers. During the Battle of Berlin, more than 2 million shells were fired into the city in three weeks. (NARA)

numerous occasions, and with little grasp of the tactical realities on the ground. Furthermore, many of the divisions he wielded on maps scarcely existed in reality.

The final acts of World War II in Europe began in January 1945, when the Soviets began their drive to the River Oder, about 40 miles (64km) east of Berlin. East Prussia

winter weather. The Red Army reached the Oder by 31 January, the Soviets massing a strength that the German Army simply could not resist. Similar stories were playing out in the Balkans and south-east Europe, although the German capacity to fight back was in many cases nothing short of miraculous.

fell between January and April (although a few isolated pockets of resistance remained), the Soviet advance spurring one of the greatest refugee evacuations in history, during which up to a million Germans died of exposure, exhaustion or merciless Soviet bombing amidst sub-zero

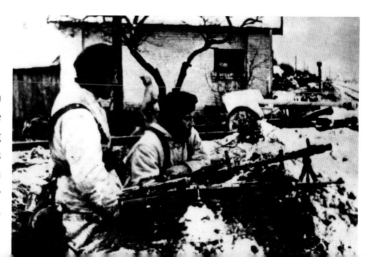

▼ *On the northern front, German troops wait in the snow with the certainty that the Soviet juggernaut will soon be upon them. The team is armed with an MG34 machine gun, which was prone to jamming in very dirty conditions such as these. (Cody Images)*

Despite being completely surrounded by Soviet forces, a recreated Army Group Centre held out in Czechoslovakia until 11 May 1945, some of its men continuing to fight the Soviets even after the official German surrender.

The reality of the war Hitler had created was now on his doorstep, although the *Führer* himself had retreated to the twilight reality of his underground bunker beneath the Reich Chancellery. On 16 April, a hammering artillery bombardment opened the Soviet offensive to take Berlin. (The

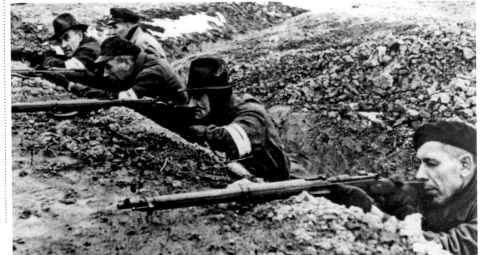

➤ *Hitler's last defence. The* Volkssturm *(People's Army) conscripted all available males between 16 and 60, and formed them into a poorly equipped militia that was utterly unable to stop the Soviet momentum. (Cody Images)*

Soviets had amassed more than 41,000 artillery pieces for the assault.) The shelling was followed by a pincer-like offensive conducted by the 1st Belorussian and 1st Ukrainian Fronts. Although the two fronts met west of Berlin by 25 April, the city's defenders (a broad mix of regular forces, paramilitary units and hastily conscripted civilians) fought with a bewildering passion, doubtless spurred on by fanatical Nazi death squads who roamed the streets, executing any who exhibited 'cowardice'. In a brutal battle that cost the Soviets more than 900,000 casualties, each street and building was steadily conquered. Adolf Hitler, the man who had dragged the Western world into ruin, committed suicide on 30 April, with Soviet forces just streets away from his bunker, and within two days Berlin was in Soviet hands.

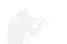

Did you know?

Hitler committed suicide along with his wife, Eva Braun, whom he had only married the previous day in a civil ceremony in the *Führerbunker*. Both bodies were incinerated in a shell hole in the gardens of the Reich Chancellery.

Although fighting would continue in places for more than a week after the fall of Berlin, the end was now inevitable. The final surrender of all German forces came on 7–8 May, and while the Allies rejoiced, Europe itself faced the prospect of rebuilding from a ruined state.

As on the Eastern Front, the Pacific theatre from 1943 was one of escalating Allied offensives, this time tightening a noose around the Japanese homeland. The shorthand term 'Pacific', however, tends to include a wider range of theatres than just

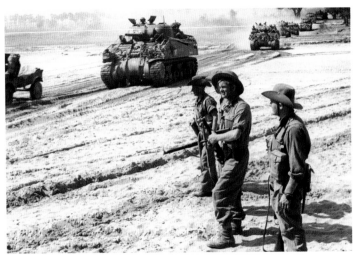

those east and south of Japan. In Burma the British, previously pushed back to the Burmese–Indian frontier, began a campaign in the Arakan region from December 1942, and in 1943 the famous 'Chindit' units of Brigadier Orde Wingate began their harassing and interdiction operations deep behind enemy lines. In the spring of 1944, a major Japanese offensive in north-western Burma resulted in the now-legendary battles to take Imphal and Kohima, which the British and Commonwealth forces repulsed. Always fighting the cruelties of climate and disease as well as the enemy, the British then steadily reclaimed Burma from a weakened Japanese Army, taking Mandalay on 20 March 1945 and Rangoon on 3 May. Meanwhile, the Sino-American Northern Combat Command under General Joseph Stilwell reclaimed much of northern

Burma, including the vital strategic town of Myitkyina in August 1944; a gain that dramatically improved Allied logistics across northern Burma and into China.

In China itself, the Japanese continued fighting a war that had been ongoing since 1937. Chinese forces were severely weakened by corruption, frequent

incompetence and infighting (not least the often open conflict between nationalists and communists), of which the Japanese took full advantage. Japanese campaigns in 1944 saw them capture many of the US 14th Air Force's airbases in southern China, which had been causing them such trouble, and it was only logistical overreach and Soviet threats from Manchuria that really prevented the Japanese consolidating their victories in that theatre.

➤ A US Marine takes a break from the fighting on Guam in July 1944. Being an amphibious force, the US Marine Corps took the brunt of many of the 'island-hopping' campaigns during World War II. (NARA)

ISLAND HOPPING

In the Pacific proper, and after much argument and debate amongst theatre commanders and the US Joint Chiefs of Staff, a two-pronged approach was adopted for the Allied campaigns of 1943 and 1944. In essence, forces under the command of MacArthur and Admiral William Halsey, commander of the South Pacific area (but largely under MacArthur's overall direction) would strike north towards Japan through the Solomon Islands, New Guinea and the Philippines (the true goal of MacArthur's ambitions), and simultaneously isolate the major Japanese supply base at Rabaul and destroy its viability through air strikes. Nimitz, meanwhile, would begin the long journey across the Central Pacific, taking the Gilbert, Marshall, Caroline, Mariana and Paula islands, and thus provide platforms

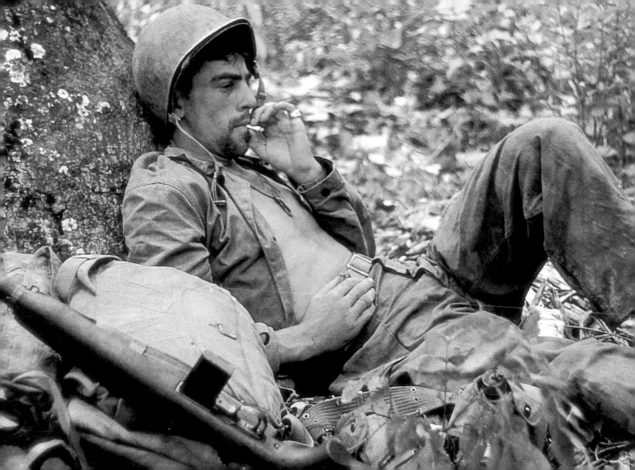

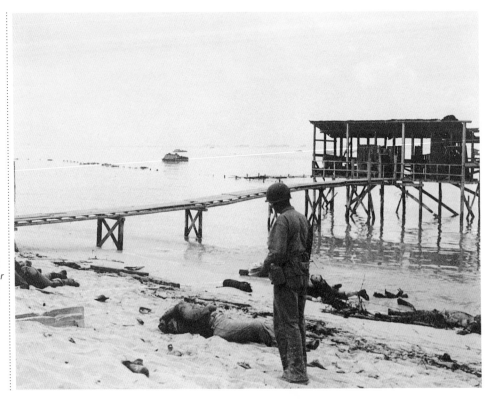

➤ On the beaches at Tarawa, a US Marine surveys the bodies of fallen comrades. Hundreds were killed or wounded at the water's edge when US forces invaded on 20 November 1943, and began a battle that resulted in more than 3,000 US casualties. (USMC)

➤➤ More scenes of devastation from the beaches of Tarawa, 1943. Early Japanese defensive tactics focused on stopping the US forces at the water's edge, but later the Japanese allowed US troops to advance inland until they met tough, pre-prepared defences. (USMC)

for launching an intensive strategic air campaign against the Japanese homeland.

From June to December 1943, the main US effort was made by MacArthur and Halsey. New Georgia was liberated by 25 August, and US Marines landed on the island of Bougainville on 1 November, while other forces occupied the western tip of New Britain. The bloody fighting in New Guinea continued, but the US, Australian and indigenous forces gradually gained the upper hand, capturing the airfields necessary to strike at Rabaul and eventually containing the Japanese forces in the mountainous northern areas of the island.

The Central Pacific campaign began in earnest, after months of build-up, with an

Did you know?

The US tactic of 'island hopping' included bypassing centres of Japanese resistance. Once they were isolated, these centres were then left to wither on the vine, meaning that some Japanese garrisons were still active on US-occupied islands at the end of the war.

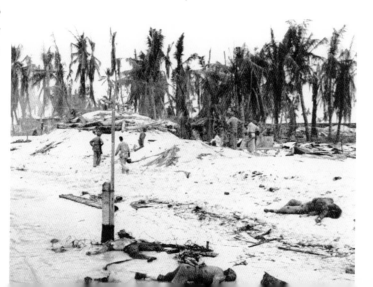

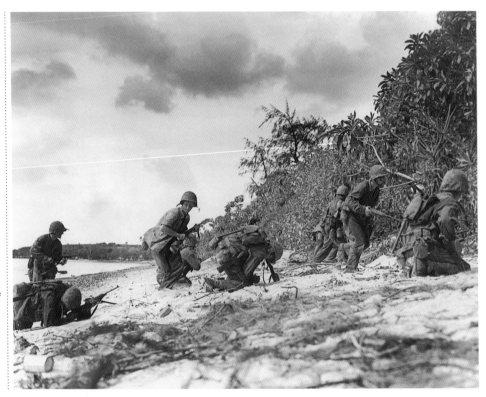

▶ Two Marines advancing onto the beaches of Saipan in the Mariana Islands, June 1944, drop as they are hit by bullets from a Japanese sniper. Japanese defenders found near-perfect concealment in the thick tropical foliage bordering the beach. (USMC)

▶▶ During the Battle for Roi-Namur in the Marshall Islands in early 1944, men of the US 23rd Marine Regiment watch as a Japanese ammunition dump in the distance blows up, producing a huge pillar of smoke. (USMC)

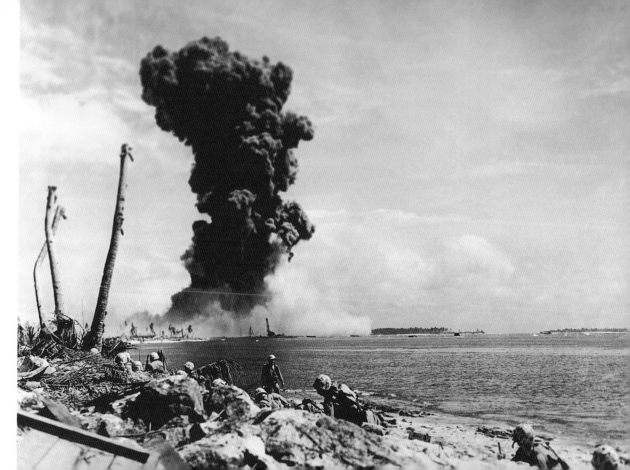

The long-range B-29 Superfortress bomber was largely responsible for delivering the US strategic bombing campaign against Japan in 1944–45. Here a flight of the aircraft return to Guam after a fire-raising attack on a Japanese city. (NARA)

Did you know?

Japanese-propagated rumours of American atrocities led to countless numbers of civilians on Okinawa committing suicide rather than surrendering to US forces. The number of suicides is uncertain, but 94,000 Okinawan civilians were killed during the battle in 1945.

assault on Tarawa in the Gilbert Islands in November 1943. In a grim augur of the future Pacific campaign, US forces suffered 3,000 casualties taking an island of less than 3 square miles (8 square km), as nearly 5,000 Japanese defenders literally fought to the death. Subsequent island objectives became bywords for attrition warfare at its worst. Clearing Saipan in the Marianas in June and July 1943 cost 3,126 US and 27,000 Japanese dead. In 1945, the battles for Iwo Jima and Okinawa, both Japanese home islands, were even more horrific. US troops had to clear every bunker, cave and trench of fanatical resistance. On Iwo Jima, for instance, 22,000 Japanese soldiers were killed – almost none surrendered – and the fighting for Okinawa was on an even greater scale, with well over 150,000 people dying on a slender island less than 50 miles (80km) long. MacArthur's forces were also having a brutal time clearing the Philippines, in a campaign that began on 20 October 1944 and continued until the very end of the war.

When Okinawa fell in late June 1945, Japan's imperial ambitions had collapsed. Parts of Tokyo and other major cities were virtually obliterated by strategic bombing, the US aircraft flying from their recently

captured island bases. The major naval and air battles around the Pacific islands, including the Battles of the Philippine Sea (19–20 June 1944) and the Leyte Gulf (23–26 October 1944), had wiped out the offensive capability of the Japanese Navy, while destroying vast quantities of enemy aircraft and poorly trained pilots. US submarines were throttling the Japanese merchant fleet. Japanese air force *kamikaze* suicide attacks were a clear sign of increasing Japanese desperation.

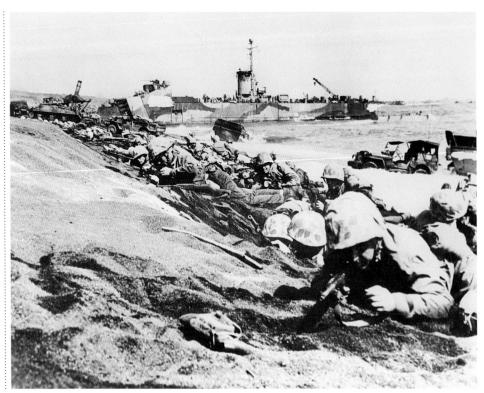

➤ US Marines flatten themselves onto the black volcanic ash of Iwo Jima, as they take extremely heavy incoming Japanese fire. Iwo Jima was one of the bloodiest battles in Marine Corps history, resulting in more than 25,000 US casualties. (NARA)

➤➤ During the feverish battle for Okinawa, a US soldier opens fire with his M1A1 Thompson submachine gun while his comrade, armed with a Browning Automatic Rifle (BAR), ducks and moves to cover. The blasted landscape indicates the ferocity of the fighting. (NARA)

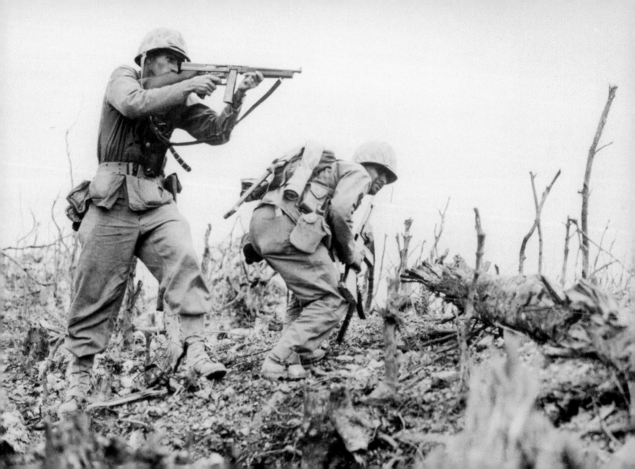

> Everything standing upright in the way of the blast – walls, houses, factories and other buildings – was annihilated and the debris spun round in a whirlwind and was carried up into the air.
>
> *– A Japanese journalist, reporting from Hiroshima*

For all the signs that Japanese defeat was inevitable, the 'island-hopping' campaign in the Pacific had unnerved the US forces and government with its heavy human cost. It was for this reason primarily that the Pacific War ended not in conventional battle, but in two atomic explosions. From 1942 the United States had taken the lead in the race to build atomic weaponry with its Manhattan Project, which allied some of the world's greatest scientists with US industrial and engineering power. On 16 July 1945, the first nuclear test took place in New Mexico, at the Alamogordo Test Range, and new devices were prepared for combat deployment.

On 6 August 1945, the Japanese city of Hiroshima was wiped out by a single bomb, dropped from a B-29 Superfortress. Some 80,000 people died within the first 60 seconds of the bomb detonating, many vaporized in milliseconds, and tens of thousands more subsequently died from wounds or radiation poisoning. Three days later, the city of Nagasaki received a similar treatment.

The atomic weapons, plus the Soviet declaration of war on Japan on 8 August, overcame any lingering intransigence towards surrender amongst the Japanese government and military leadership. On 15 August, the Japanese emperor made a radio

broadcast declaring Japanese capitulation, and on 2 September the Japanese foreign minister, Mamoru Shigemitsu, signed the official surrender aboard the battleship USS *Missouri*. World War II was over.

Did you know?
The Manhattan Project was one of the largest industrial enterprises in US history. The total workforce numbered more than 600,000 people, and the total cost was £2 billion.

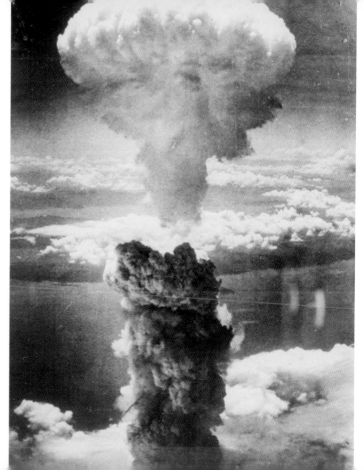

➤ *A mushroom cloud towers above the Japanese port city of Nagasaki on 9 August 1945. By the time this photograph was taken, up to 70,000 people lay dead or dying in the streets below. Thankfully, this was the last act of atomic destruction of the war. (NARA)*

World War II left a mark on history that cannot be overstated. An estimated 56 million people had died, including 20 million Soviets, a similar number of Chinese, more than 5 million Germans, 450,000 British and 416,000 Americans. Civilians constituted the bulk of the overall death toll, the victims of bombing, starvation, the disease that always accompanies war, and outright genocide. The Allied victory against Hitler brought to light the Nazis' programme of mass extermination against Europe's Jews, revealing that some 6 million men, women and children had been murdered between 1941 and 1945, most of them in the gas chambers of death camps like Auschwitz, Treblinka and Chelmno. Although what we now call the Holocaust is a unique act of violence in human history, direct, coordinated violence

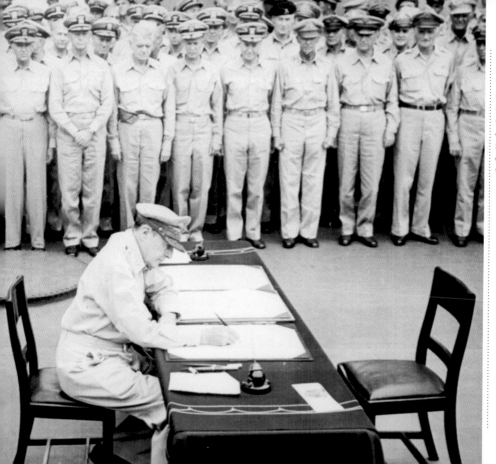

◄ *Aboard the USS Missouri on 2 September 1945, General Douglas MacArthur puts his name to the document declaring Japan's official and unconditional surrender, bringing to an end six years of global war. (NARA)*

against civilians was unfortunately a central ingredient of the overall conflict.

Nor did the end of war bring a peaceful world. It had been Hitler's late hope that the capitalist West and communist Soviet Union would ultimately turn on each other and spare Germany's final defeat. Such was not to be, but the world war did give way to the Cold War, in which the opposing ideological blocs fought each other through a massively expensive arms race and via proxy conflicts around the world that also cost millions of lives.

There are glimmers of light from the war. The Allied effort saved countless millions of people from brutal occupations and persecutions, and removed some of history's most evil individuals from positions of power. Brutality and violence were also balanced by acts of heroism, humanity, compassion and integrity, showing human beings at their very best as well as their very worst. Although, at the time of writing, the war began more than 60 years ago, in many ways we are still living with its legacies.

Beevor, Anthony, *Stalingrad* (London, Penguin, 1999)

Clark, Alan, *Barbarossa: The Russian–German Conflict 1941–45* (London, Phoenix Press, 2000)

Collier, Paul (*et al.*), *The Second World War: A World in Flames* (Oxford, Osprey, 2004)

Dear, I.C.B. (ed.), *The Oxford Companion to the Second World War* (Oxford, Oxford University Press, 1995)

Ellis, John *The World War II Databook* (London, Aurum, 1995)

Flower, Desmond, and James Reeves (eds), *The War 1939–45: A Documentary History* (New York, Da Capo, 1997)

Hastings, Max, *Retribution: The Battle for Japan, 1944–45* (London, HarperPress, 2007)

Keegan, John, *The Second World War* (London, Viking, 1990)

Nalty, Bernard C. (ed.), *The Pacific War* (London, Salamander, 1999)

Rees, Lawrence, *The Nazis: A Warning from History* (London, BBC, 1997)

Young, Peter (ed.), *Atlas of the Second World War* (London, Cassell, 1999)

■ ISBN 978 07524 6203 5

■ ISBN 978 07524 6204 2

■ ISBN 978 07524 6192 2

■ ISBN 978 07509 4399 4

■ ISBN 978 07509 4487 8

■ ISBN 978 07524 6193 9